IMAGES
of America

BATH AND ITS NEIGHBORS

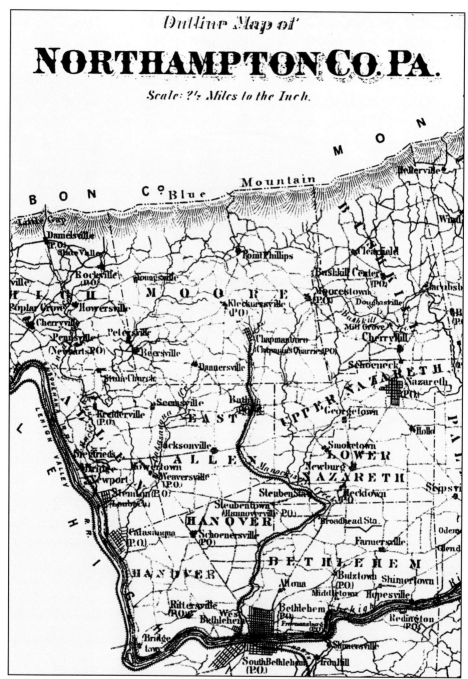

Bath takes its founding date of 1737 from a 247.5-acre land grant to Daniel Craig for what became known as Craig's Settlement in the beautiful Monocacy Valley. It was the first settlement by white people within the forks of the Delaware River. The western branch of the Monocacy Creek flows through the center of Bath. This 1874 map, showing Bath's central location in Northampton County, was published by A. Pomeroy and Company in Philadelphia. (Author's collection.)

On the cover: Please see page 103. (George Dech.)

IMAGES
of America

BATH AND ITS NEIGHBORS

Carol K. Bear Heckman

ARCADIA
PUBLISHING

Published by Arcadia Publishing
Charleston, South Carolina

Printed in the United States of America

Library of Congress Catalog Card Number: 2006923343

For all general information contact Arcadia Publishing at:
Telephone 843-853-2070
Fax 843-853-0044
E-mail sales@arcadiapublishing.com
For customer service and orders:
Toll-Free 1-888-313-2665

Visit us on the Internet at www.arcadiapublishing.com

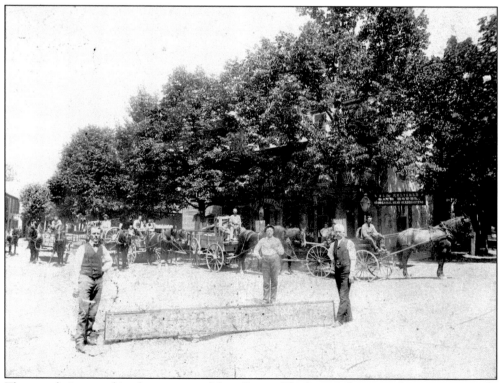

The parade is paused in the square on Main Street. The banner between the two men reads, "McCormick Harvesting Machines." Behind the horses and wagons is the Bath Hotel. A curved signboard between the center porch posts reads, "John P. Schott." He was the 11th proprietor and owned the hotel around 1900. The sign to the right, at the entrance to Chestnut Street, reads, "Old Reliable, Bath Hotel, Commercial Men's Headquarters." (Bath Museum.)

CONTENTS

Acknowledgments 6

Introduction 7

1. The Village of Bath: 1737–1855 9

2. Bath Borough: 1856–1911 25

3. Bath, the Hub: 1912–1936 45

4. We the People of Bath: 1937–1987 61

5. North: Chapman, Crossroads, Klecknersville,
 Point Phillips, and Copella 81

6. East: Penn-Allen and Rising Sun 103

7. South: Irish Settlement 109

8. West: Franks Corner and Weaversville 117

ACKNOWLEDGMENTS

Bath and Its Neighbors would not exist without the photograph finesse of my husband, Darrin. Darrin, you are priceless! Thank you Marjorie Rehrig, Agnes Melinsky, and Evelyn Hartzell, founders of the Bath Museum (a marvelous asset for Bath), for giving me access to all of the museum's treasures. Thanks to the Governor Wolf Historical Society (GWHS) for allowing me to use items from its museum. Thank you Bill and Dave Halbfoerster (*Home News*) and Michael Duck (*Morning Call*) for getting the word out about my search for photographs. Thanks to all the people who shared their pictures and stories with me: Carl Rehrig, Catherine Hahn, Elizabeth (Mayor Betty) Fields, George and Annabelle Dech, Carol and Don Keller, Carol Zader, Dennis and Jane Borger, Bill Werner, Robert and Pauline Werner, Virginia Bittenbender, Edwin and Joanne Keller, Scarlet Erdosy, Susan Kirk, Carl and Evelyn Becker, Sylvia DeRea, Doris Burritt, Mary Ellen Bittenbender, Jason Harhart, Laura George, Joseph George, Robert Graver Jr., Betty and Robert Boyle, Loretta Kotowski, Catherine Zakos, Robert Fehnel, Peter Rohrbach, Ruth Graver, Josef Guenther, Brenda Summers, Ann and Gordon Bartholomew, Lori Gilbert, Karen Grube, Sharon Longenbach, Annie Greene, Keith Greene, Mae and Dale Day, Thomas and Shirley Erkinger, Harry Holub, Hattie Groller, Ida Gossler, Ruth Himler, Larry Kemmerer, Edwin and Dolores Schall, Shirley Hader, Abby Spencer, Steve Hilberg, Dianne and Donald Kmieczak, Deanna Eberts, Jeff Eberts, Janice Grube, Harvey Haupt, Bruce Swan, Linda Flory, and Paul and Lillian Dech.

Thanks to the people who made life easier for me and gave scans to me: Stephen Nikles of Copiers Inc., Tim Herd, Darrell Mengel, Kay Tomko, and Michael Kocher.

Thanks to the museum volunteers and employees who listened patiently to my questions: Sharon Gothard (Easton Public Library), Jill Yonkin (Lehigh County Museum), and Colleen Lavdar and Jane Moyer (Northampton County Historical and Genealogical Society).

Thanks to Sean and Johanna Billings for getting me started. Proofreaders Marjorie Rehrig, Anna Gilgoff, and Peter Cellucci, thank you for fixing my blunders.

Thanks to the keepers and recorders of Bath's rich history: Asa McIlhaney, Rev. Reginald Hellfrich, Elias Spengler, Tim Herd, Delbert Siegfried, and Majorie Rehrig.

Thanks to my children, Matthew and Rachel Stirling, who inspire me to think outside the box and take on new challenges (like writing a book). And finally thanks to my mom and dad, Rachael and Russell Bear, who taught me to cherish family, our heritage, antiques, and funny cake.

INTRODUCTION

Bath is a special little town. The early settlers who flocked here were in search of a better life. Hardworking, gutsy, and innovative, they settled in this green valley watered by the west branch of the Monocacy (a Native American term meaning "white bear") Creek, protected by the hills. Bath flourished and became a thriving commercial hub, a center of entertainment, and a wonderful place many call home.

The first year I lived in Bath, I took a walk with my two-year-old son. We stopped to watch a street crew at Northampton Street and Old Forge Drive. As we started to walk away, one of the men came over to us, reached in his pocket, pulled out a coin, and pressed it into my hand. He said, "This is for your son when he gets older." It was a silver dollar. That's Bath in a nutshell: spontaneous, surprising, giving, and believing in the future.

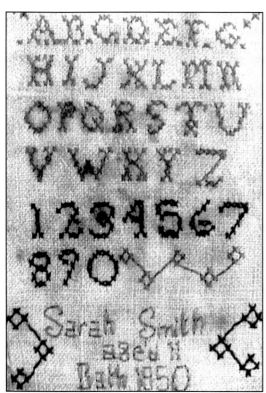

Sarah Smith, age 11, practiced her needlework skills in this sampler dated 1850. (Author's collection.)

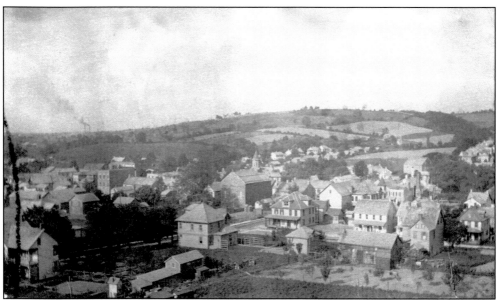

This bird's-eye view of Bath from Mount Wolf was taken in the early 1900s. The street in the left foreground is Northampton Street (formerly Mill Street and Easton Road). The church in the center is the back of Christ Church on Chestnut Street. The tall flattop building to the left is the rear of the Barrall building. Past it in the distance, note two stacks of the Bath Portland Cement Company. On the right, the large building against the trees at the end of Northampton Street is the Siegfried Mill. (Author's collection.)

One

THE VILLAGE OF BATH
1737–1855

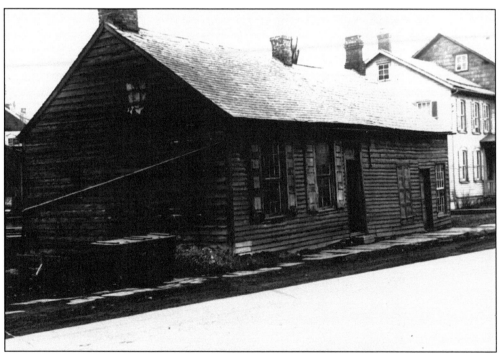

The Abraham Engleman clapboard-covered log house, built in 1765, stood on West Main Street on the northwest side of the Race Street intersection. This is the oldest house in Bath documented in a photograph. The railroad tracks passed between the log house and the white house on the right. Engleman's daughter married Moses George, the cigar maker. The house was torn down in 1930. The oldest building documented in writing is the tannery built by Arthur Lattimore before the Revolution. His log home was probably the first house in Bath. The tannery was located north of the intersection of Main and Northampton Streets. (Bath Museum.)

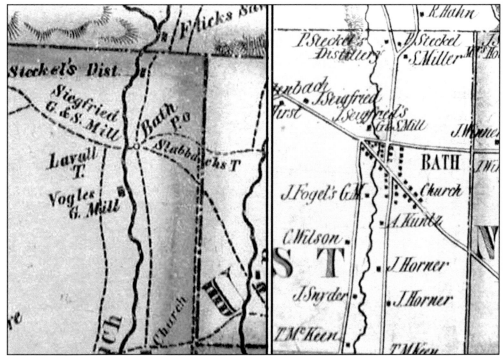

These are the earliest maps of Bath. The left map is from an 1851 map of Northampton County by M. S. Henry engraved on stone. The right map is from an 1855 map of Easton and 12 miles around published by J. D. Scott, 116 Chestnut Street, Philadelphia. In 1840, the census gives the population of Bath as 286 and in 1850 as 375. (Easton Public Library.)

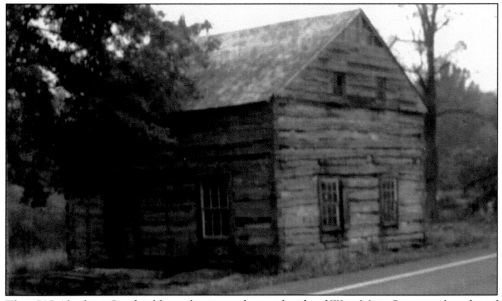

The 1785 Abraham Siegfried log cabin is on the south side of West Main Street at the edge of town. Inside, the first floor has a large keeping room with a walk-in fireplace and two smaller rooms. The second floor is one room. The cabin still stands. The family cemetery is across the street. (GWHS Museum.)

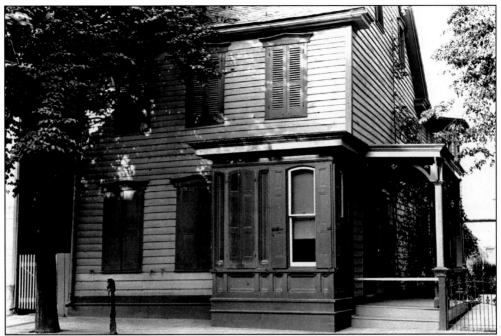

The 1799 Sensenbach house is at 115 South Chestnut Street. South Chestnut Street still retains all of its original structures spanning the years 1799 to 1900. (Bath Museum.)

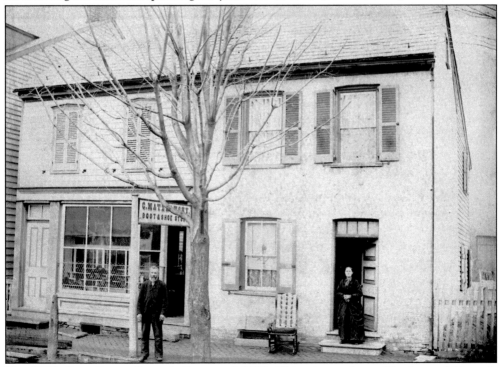

The "Old Grey Cottage" was built around 1800. This picture shows Charles and Hannah Matzkowsky in front of their boot and shoe store in 1907. Charles served on town council from 1880 to 1891. The cottage is located at 224 South Walnut Street. (Michael Kocher.)

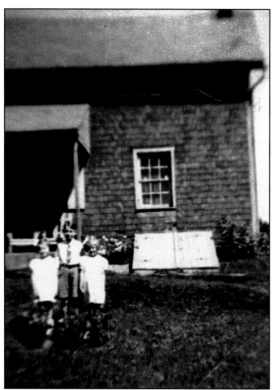

This slate-sided log cabin stood high on the west side of Route 512 at the north edge of town until the mid-1950s. Taken in 1942, this picture shows, from left to right, Polly, Ray Jr., and Betty Mast, ages 7, 10, and 8, in front of their home. The log cabin had four rooms total: a kitchen, a living room, and two bedrooms. Betty recalls sitting on the 12-foot embankment overlooking the road and catching cupcake packs tossed by the Spalding Bakeries truck driver. (Betty Boyle [née Mast].)

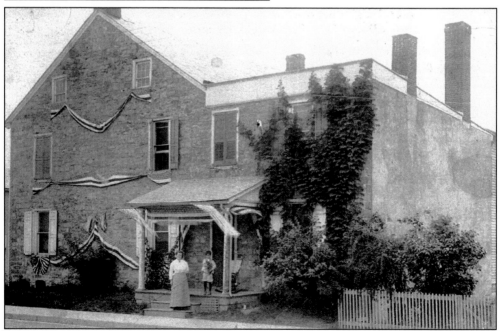

Daniel Sr. and Rebecca Steckel built this stone house at 207 West Northampton Street in 1804 on land given to them by her father, Jessie Jones. They had six children. Daniel ran the tannery, a distillery, and a farm. Active in his community and his church, Daniel died at age 101. This photograph shows the Chestnut Street side of the house during one of the town celebrations. (Bath Museum.)

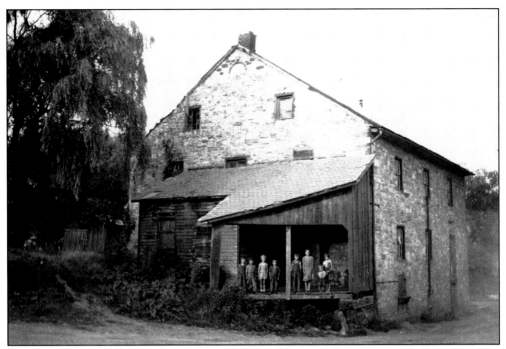

Vogel's Mill, later L. Barber's Saw and Grist Mill and the Bath Creamery, was built in 1812. The photograph shows the frame addition on the west side. The stone mill was on the northeast corner of Water Street (now Race) and Grain Alley (now Mill Street). (Bath Museum.)

No. 7

Bath, *Northampton County,*
December 21, 1816.

I do hereby certify and promise to convey unto the bearer hereof, and to his heirs, by a good and clear deed, such part of the property which shall be determined against its number hereto affixed, situate in the said village of Bath, and adjacent thereto, as described by a certain draft of division of property, under my hand and bearing even date herewith.

DIVISION AND SALE OF PROPERTY.

The Subscriber offers for sale the following property in fifty-seven shares at one hundred dollars each, to wit :

Thirty-Three Lots in the Village of Bath,

In the county of Northampton, one of which contains an acre, surrounded by streets and alleys, with a frame dwelling-house long occupied as a store, and a new frame store-house and stables.

In 1816, Col. James Ralston laid out town lots in Bath. At that time, there were five dwellings, two stores, a tannery, and a gristmill. This document is a receipt for lot No. 7 and an advertisement for the sale of 33 one-acre lots in the village. (Bath Museum.)

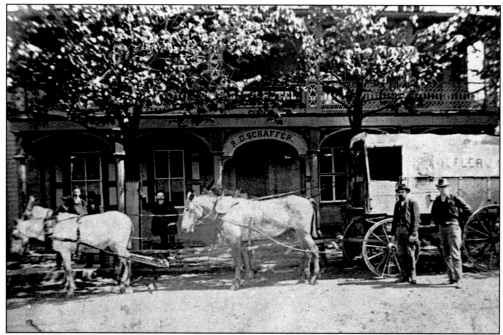

The Bath Hotel, on the northwest corner of the square, was built in 1817. The name in the arch refers to Richard D. Schaffer (above), who was the 8th owner, and to G. S. Hackman (below), who was the 12th owner. The first village tavern was a red, weatherboarded log building on the northeast corner of the square run by Jacob Vogel. But as the town grew, Vogel needed more space, and he built this stone hotel. The photograph above is from 1880 to 1890, and the postcard below is from 1910 to 1920. Throughout the 1800s, extensive improvements were added to the hotel to keep up with the times; the frame section was added to the left, the third floor was added, and caps were added over the windows. (Above, Bath Museum; below, Dolores Schall.)

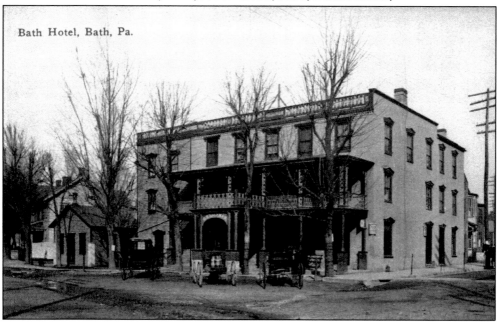

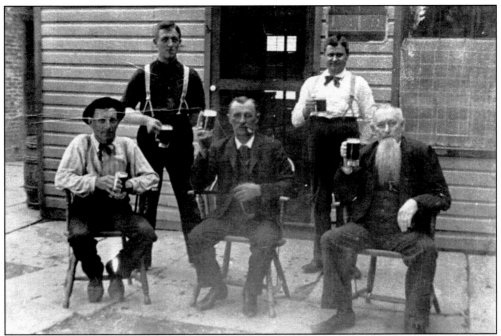

This *c.* 1890 photograph was taken in front of the Bath Hotel barroom. Note the Uhl's Lager sign to the right of the door. The gentlemen enjoying a brew and watching the action in the square are, from left to right, (seated) Uriah Nagel, carpenter; James Beidler, contractor; and Reuben "Snap" Siegfried, bartender; (standing) unidentified and Emerson Bilheimer, bartender. The building at the left was the toilet. (Bath Museum.)

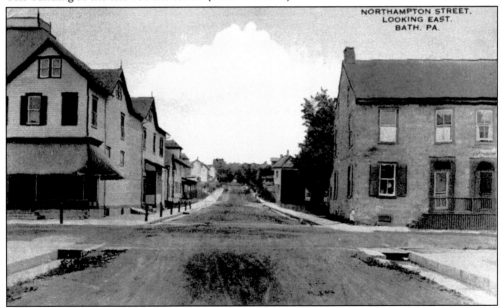

This postcard is a view eastward on Northampton Street from the Chestnut Street intersection. The 1822 stone house on the far right corner was the home of Joseph Steckel. Joseph was the son of Daniel Steckel Sr., who lived on the opposite corner. The second door on the front of the house may have been the entrance to Eliza's, Joseph's wife, millinery business. (Bath Museum.)

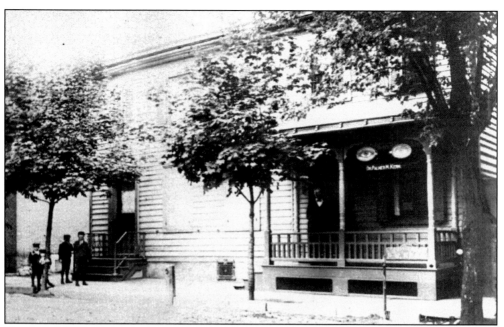

Shown in the picture is 125–127 South Chestnut Street, the office of Dr. Palmer M. Kern. While four children watch shyly from the alley, Dr. Kern poses on the porch. The building was constructed about 1850. (Bath Museum.)

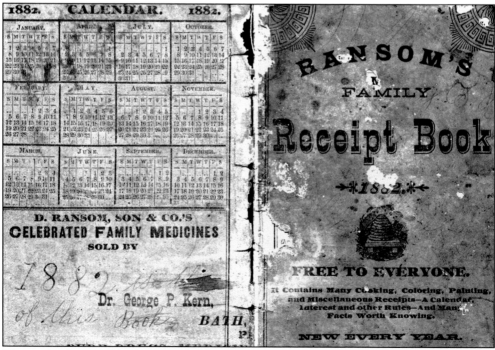

This is the front and back cover of a free Ransom's Family Receipt Book from 1882 that Dr. George P. Kern distributed to his clients. It contained recipes for green gooseberry tarts, bubble pudding, mustard pickles, and marbled cream candy. It also states at the end, "If the Receipts make you sick, the Medicine will cure you." (Bath Museum.)

This photograph shows the window of the Homeopathic Hospital at 129–131 South Chestnut Street, just right of Dr. Kern's office. Here, in 1829, Dr. William Wesselhoeft established the first homeopathic school of medicine in America, the start to the Hahneman Hospital in Philadelphia. His first surgical technique, the successful removal of a cataract, brought him much fame and attracted many students and doctors to Bath. As of 1901, there had been 39 physicians, surgeons, or dentists who had at one time resided in Bath. (Bath Museum.)

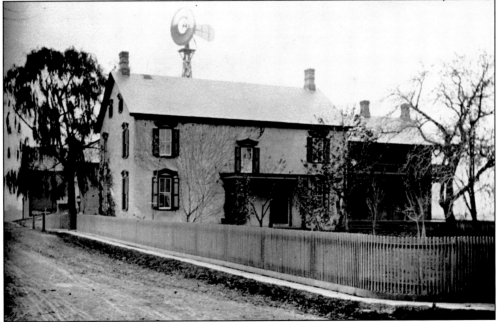

This photograph shows Walnut Street leading south out of town. This is a rear view of the stucco-over-stone house built in the early 1880s that once stood at the southwest corner of Walnut and Mill Streets. The parlor had a slate fireplace mantel faux-painted to look like marble. (Bath Museum.)

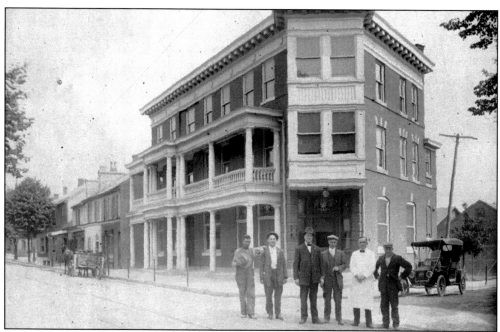

Bath, already noted for its sleighing parties, became equally popular for visiting, feasting, and dancing. In 1834, Jacob Vogel built a second hotel at the southeast corner of Main and Walnut Streets. At first called the Bull's Head Tavern, it became known as the American Hotel. In the early 1900s, it was torn down, and the "New" American Hotel was erected in its place. Above is a picture of the American Hotel taken around 1910. Elaborate stained-glass windows top the entrance at the corner. Standing are, from left to right, Howard Landis, Charles Medler, unidentified, George Sherer, Louis Hordendorf, and unidentified. Below is a picture of the interior and the bar. Note the marble bar rails and the cut-glass panels in the bar base. (Above, Bath Museum; below, Darrell Mengel.)

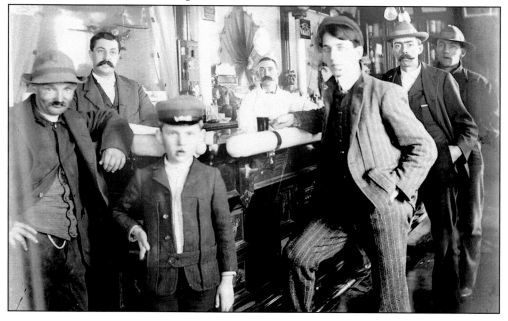

Trade cards of the 1800s are more abundant than photographs. Sometimes the American Hotel was referred to as the American House. The back of this card is an advertisement for Sachs-Pruden's Ginger Ale. The owl wedding scene is a pun on the word "consumation." (Bath Museum.)

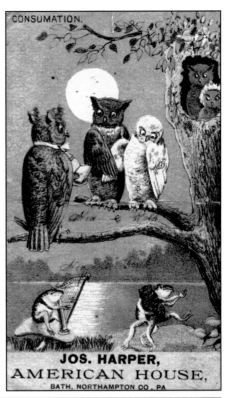

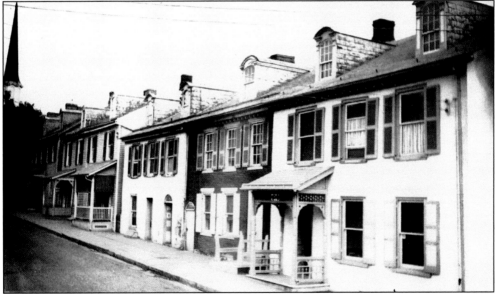

Just past the American Hotel, Vogel built these houses along the south side of East Main Street. The stucco-over-stone at 124 was built in 1839, and the brick houses at 126 and 128 were built in 1844. The dark brick house (126) had a beehive oven in the basement and a tunnel that went under Main Street to the north side. They still stand, continuing to St. John's Church in the distance. Note the dormer windows, wood dentils in the cornice, shutters, and porch trim. (Bath Museum.)

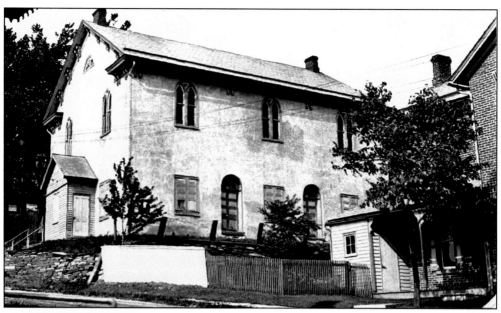

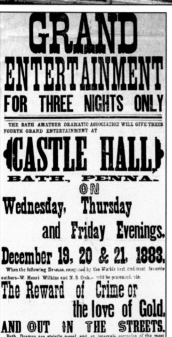

In 1833, Daniel Steckel Sr., Peter Lichtenwalner, Jacob Vogel, Jacob Snyder, and John Windt formed a committee to build a church. In 1834, the Bath Kirche (above) was completed on the east side of Washington Street, between Main and Penn Streets. It was a Union church, used as a place of worship by Reformed members and Lutherans. It was 40 by 56 feet and seated over 600 people. The service and singing was all in German. One special service was held on the last evening of the year. It attracted people from miles away with its evergreen decorations, 365 candles, and special music. In 1876, the congregations built their own churches, and the Kirche was sold to fraternal members. A second floor and a stage were added, and it became Castle Hall. The large poster (left), printed in town by Thomas D. Laub, advertises two "strictly moral" dramas by the Bath Amatuer Dramatic Association. Adult tickets for seats on the wooden benches were 25¢, with reserved seats 10¢ extra. The building was razed in 1915 for the new brick school. (Above, Bath Museum; left, Harry Holub.)

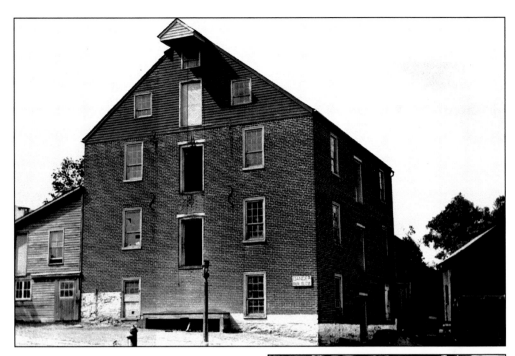

The brick Joseph Siegfried gristmill (above) was built in 1845. It stood at the northwest corner of the intersection of Main and Northampton Streets. Note the old kerosene lamppost in front. The grain was raised to the third floor and lowered through square wooden chutes while being ground on millstones into chicken feed, flour, or cornmeal. Roasted corn became golden meal that became fried mush smothered with butter and molasses at breakfast. The waterwheel (right) powered the whole operation with a fall of 20 feet of water from a millrace bypassed from the Monocacy Creek. (Above, Bath Museum; right, GWHS Museum.)

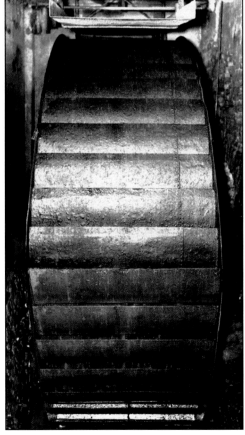

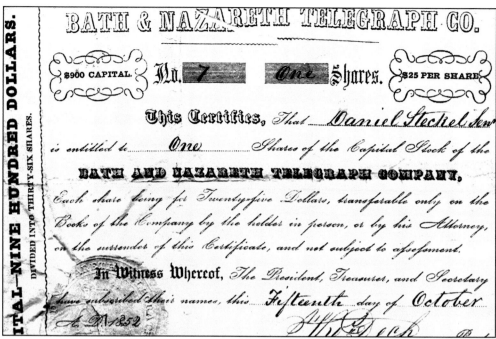

This is an 1852 share certificate for the Bath and Nazareth Telegraph Company. It entitles Daniel Steckel Sr. to one share for a price of $25. (Author's collection.)

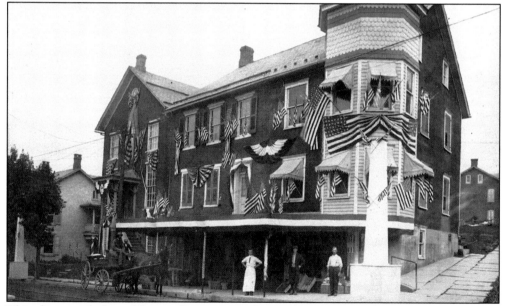

This photograph shows Rhymer Groceries on the northwest corner of Main and Washington Streets. To the left of the grocery store is Malta Hall, built in 1855. Malta Hall is a three-and-a-half-story brick building with multipaned windows and a large entrance porch and steps. In 1874, it was Bath Marbleworks, owned by Jeremiah Reinhard. It manufactured marble mantels, monuments, tombstones, and brownstone. Later it became Carpenter Hall, Bath High School, Scout Hall, Bath Public Library, and more. This Old Home Week photograph was taken in 1912. (Harvey Haupt.)

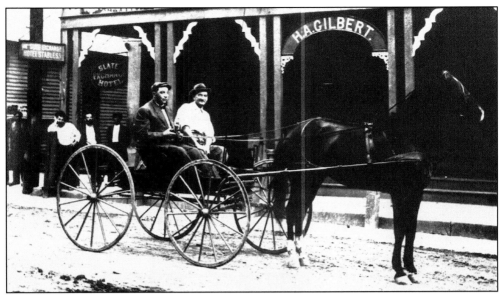

This photograph shows Harry Wind (left) driving the horse Star in front of the Slate Exchange Hotel. William Wind, Star's owner, was the operator of the livery stable behind the hotel. Note the hand sign pointing down the alley. The name board, H. A. Gilbert, indicates the hotel owner. The Slate Exchange Hotel, the third hotel in town, was built on the south side of the square in 1853 by Samuel Straub. There were two stage lines from Easton to Mauch Chunk through Bath and another from Bethlehem to Bath. Each team was made up of four grays and a Troy coach that seated nine inside and six outside. Jacob Siegfried, who lived in a log cabin across from the Rising Sun, was a popular driver. His team would do a figure eight in the square as he blew his horn announcing his arrival. The stages were discontinued with the advent of the railroad. (Edwin Schall.)

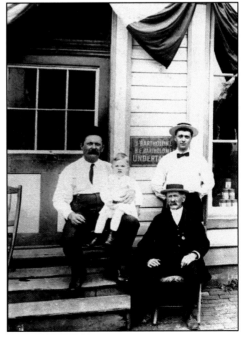

This photograph shows four generations of Bartholomews in front of their store at 124 West Main Street. They were undertakers but also dealt in furniture. From left to right are (first row) Josiah Bartholomew; (second row) James F., Randolph H., and Harry E. Bartholomew. The family business started in 1853 and continues today with James R. at 243 South Walnut Street. (Bath Museum.)

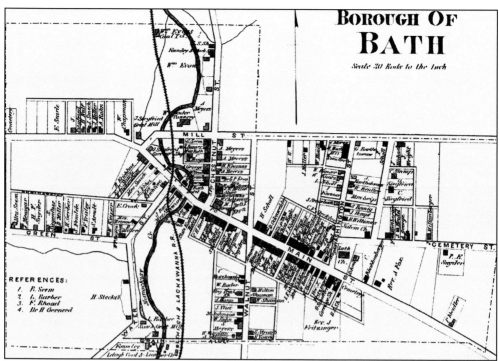

This 1874 map was published by A. Pomeroy and Company in Philadelphia. In 1860, the census gives the population of Bath as 486 and in 1910 as 1,057. By the late 1800s, there were almost 100 different businesses in Bath. In 1855, 48 residents petitioned that Bath be incorporated as a borough. On March 21, 1856, the new borough held its first elections in the public house of Samuel Straub, the Slate Exchange Hotel. James Vliet, Esq., was chosen as chief burgess. (Author's collection.)

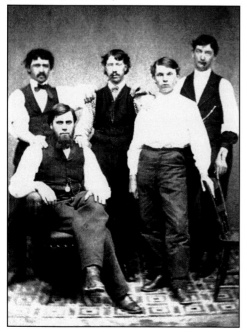

This is a picture of Moses George Cigar Factory workers. Moses George, the owner, is seated at left. He came to Bath in 1859 and at age 16 started making cigars. By the 1890s, his trade had extended west to Colorado and south to North Carolina. (Bath Museum.)

24

Two

BATH BOROUGH
1856–1911

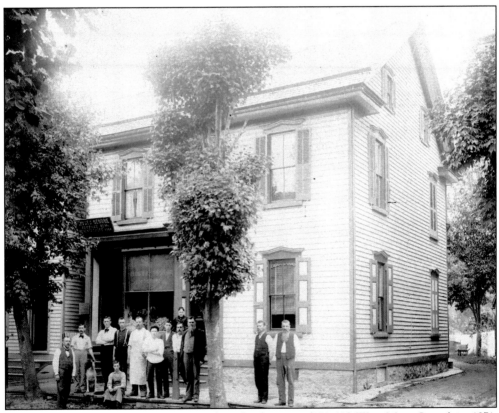

The Moses George Cigar Factory moved to this location (111–113 West Main Street) in 1871. The factory was in the barn at the rear of the property and was known as one of the largest cigar factories in the country. The barn burned, but the house still stands. (Bath Museum.)

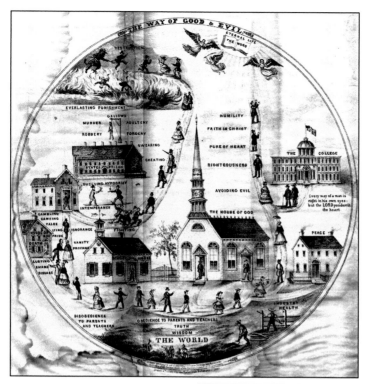

This print titled *The Way of Good & Evil* was drawn and published by John Hailer, Bath, Northampton County, in 1862. (Bath Museum.)

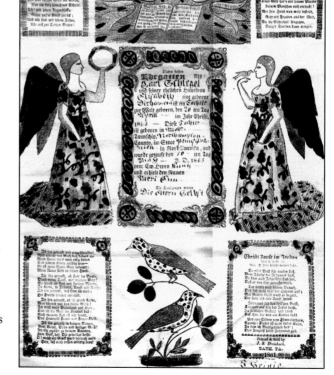

This *geburts und taufschein* (birth certificate) was also printed in Bath. At the bottom right it reads, "printed & sold by J.S. Dreisbach, Bath Pa 1861." Below that is the signature of the artist, J. Heinie, who decorated it with bold watercolors. The certificate records the birth of Meri Ann Schlegel, born April 20, 1863, in Mohr Township. (Author's collection.)

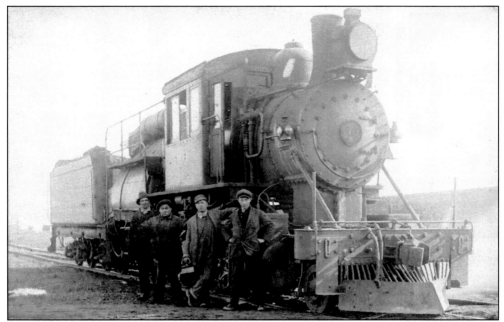

The Lehigh and Lackawanna Railroad came to Bath on Thanksgiving Day 1867. Four round-trip excursions were run from the North Pennsylvania depot, South Bethlehem, for a fare of 75¢. In later years, the train continued to Chapman. Pictured with an engine are, from left to right, Chet Sherer, Frank McIlhaney, Harry "Goody" Guth, and Joe ?, possibly on the side rail near the station. (Gordon Bartholomew.)

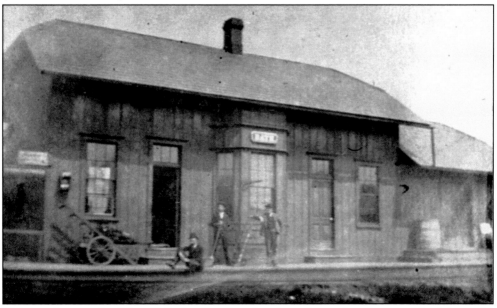

This is a photograph of the old Bath railroad station. It was located on the east side of the tracks near the livery stable behind the Slate Exchange Hotel. Marjorie Rehrig remembers standing at the station waiting for the World War II troop trains. She and other young girls would hand off rolled-up magazines and newspapers with fruit and, of course, their address inside as the trains went past. (Bath Museum.)

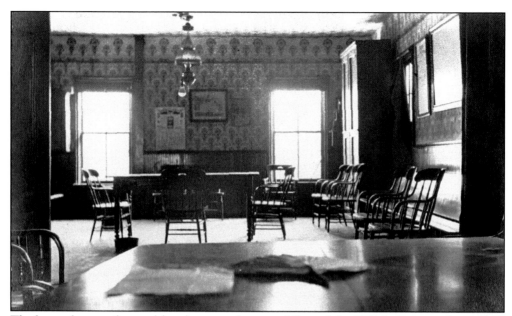

The borough council room (above) was on the second floor of the 1868 firehouse and town hall at 135 East Main Street. The windows overlook Main Street. Note the hanging kerosene light over the table. The chairs are presently used in the Bath Museum. On the first floor (below), big doors opened to let the fire equipment out. At the back are two jail cells. The building still stands. (Bath Museum.)

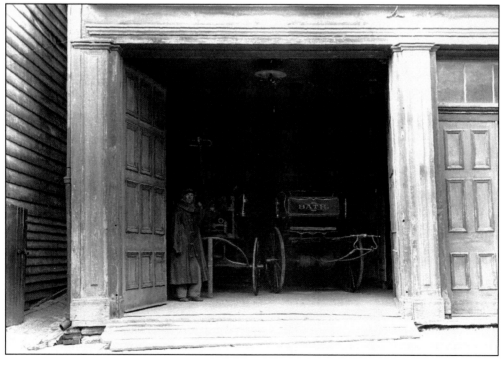

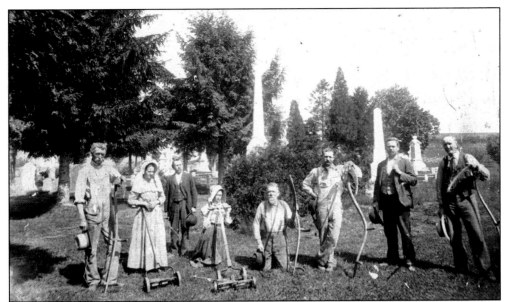

Green Mount Cemetery was started by John Snyder in 1859 and incorporated in 1872. This photograph shows the grounds committee. The cemetery has a book of rules. Rule No. 9 is "No horse shall be driven or ridden within the cemetery limits, at a rate not faster than a walk." The oldest person buried in the cemetery is Daniel Steckel Sr., who died in 1868 at age 101 years, 17 days. Green Mount abuts Northampton, Broad, and Penn Streets. (Bath Museum.)

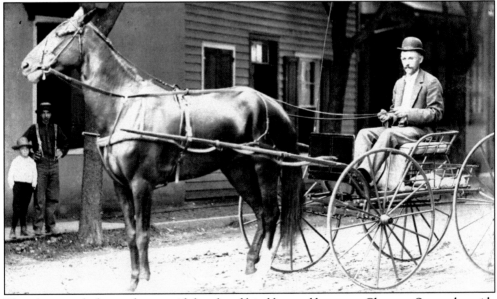

This photograph shows a horse, with bandaged hind leg, and buggy on Chestnut Street alongside the Bath Hotel. One reason people flocked to Bath was horse racing. In 1875, a driving park was opened on 18 acres of Chris Straub's farm located past the end of Sleepy Hollow Road just north of town. The first race included horses owned by Dr. Palmer M. Kern and Chris Straub, but the winner was Bob Demster's horse Bonnie for a purse of $200. The park had a high board fence, a refreshment stand, and, eventually, a grandstand. Entertainment included the Bath Band and a 25-foot slippery pole with a $5 gold piece on top. (Bath Museum.)

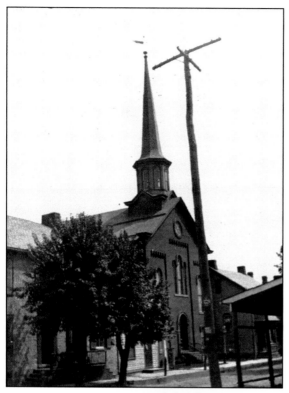

Christ Church was built at 109 South Chestnut Street in 1876 by the Reformed group from the Kirche. This view (left) is south on Chestnut Street from Northampton Street. To the right of the church is the parsonage. To the left on the corner is Joseph Steckel's house. The frame addition held a photographer then a barbershop. Across the street, the house on the corner (100 South Chestnut) was for a time a Bartholomew furniture store, a movie house, and a temporary place of worship for the Catholics while their church was being built. Christ Church was constructed by Samuel Meyers. The Kirche's beehive pulpit is in the community room, the furnishings were built by Josiah Bartholomew, and the stained-glass windows document many contributing townspeople. In the 1900s, the Sunday school (below) met on the balcony. In those days, a hat and a dress was standard attire for a young lady on Sunday morning. (Bath Museum.)

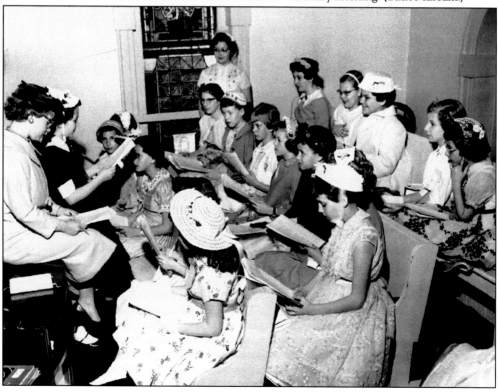

St. John's Church was built in 1876 at 206 East Main Street by the Lutheran group from the Kirche. The cost of construction was estimated to be $18,000. The congregation at that time was over 300 members. Just east of the church is the old Union cemetery used by the Kirche. The land was donated by Jacob Vogel for use as a God's acre. Interment ceased when Green Mount Cemetery was opened. The cast-iron fence was added later. (Bath Museum.)

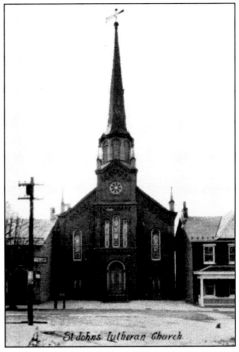

St Johns Lutheran Church.

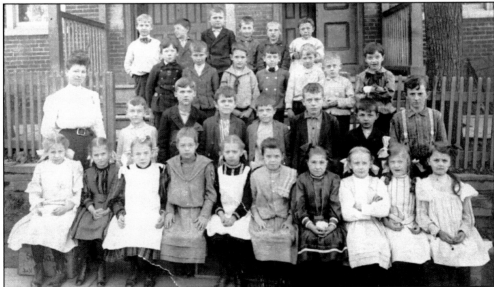

This 1906 picture is the second-grade class in front of the north entrance to the public school. Built in 1883, it was the third school at this location. It was brick and two and a half stories. Pictured are, from left to right, (first row) Elsie Motson, Helena Burnhart, unidentified, Alberta McCoy, Olivia Hess, ? Fogel, Gertrude Schisler, Helen Smith, Irene Laub, and Bessie Fehnel; (second row) Miss Fenner (teacher), Allen Scheffler, Stewart Smith, Frank Vogel, Tom Hugo, John Palmer, Walter Frey, and Howard Bartholomew; (third row) Arthur Eberly, William Frey, James Lerch, Franklin Miller, Sam Bartholomew, Isaac Miller, and Donald Helffrich; (fourth row) Ernest Odenwelder, unidentified, James Small, Leslie Siegfried, Ronald Flexer, and Joseph Hugo. (Bath Museum.)

The brick Worman house at 257 South Walnut Street was built in the 1850s. In 1885, there were Wormans who had a bookstore and a milliner shop, both on Main Street, and one with a coal business on Chestnut Street. This photograph was taken in 1906. Later a wooden porch was added to the front and the north side. The house still stands. (Bath Museum.)

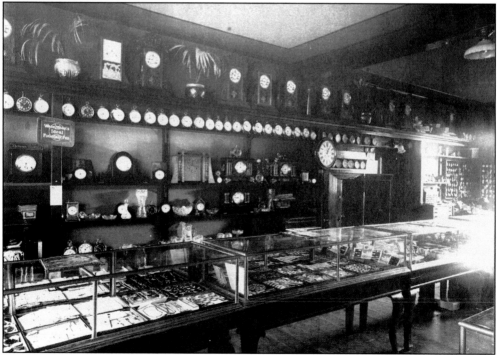

This is the interior of Miles P. Kummerer's jewelry store at 116 East Main Street. His name is printed over the safe in the wall. He carried a large selection of jewelry and clocks. (Catherine Zakos.)

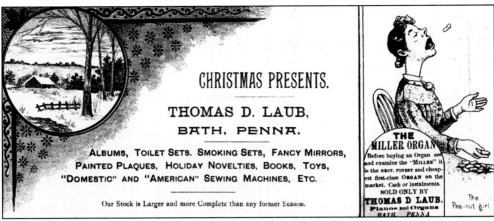

Many businessmen had more than one business interest. The Bartholomews had undertaking and furniture making. The Steckels had a farm, a tannery, and a distillery. These two cards from Thomas D. Laub show, in addition to being a printer, he sold everything from gifts and sewing machines to organs and pianos, perhaps at different times. The left card is dated 1886, and that store was at 89 Main Street. (Left, Elizabeth Fields; right, Bath Museum.)

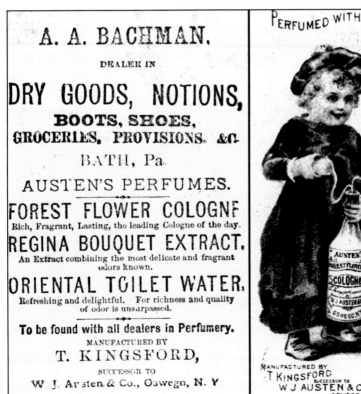

This photograph shows the front and back of a perfumed trade card distributed by A. A. Bachman in 1889. Bachman's general store was on Chestnut Street. (Bath Museum.)

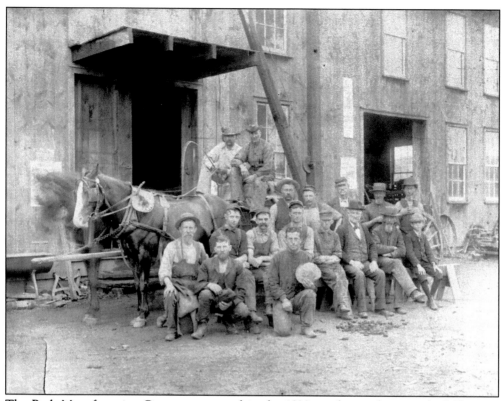

The Bath Manufacturing Company operated in the 1890s at the northwest end of Chestnut Street. Its sales receipt reads, "manufacturers and dealers in agricultural implements, slate-quarry machinery, mill work, steam pumps, boilers and hoisting machines (successors to Smock & Knauss)." The leather harness on the horse is marked "Bath Mfg. Co." The sign to the right behind the men reads, "Adriance Binders, Reapers, Mowers." This wooden building no longer stands. (Bath Museum.)

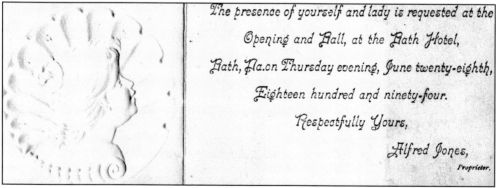

The presence of yourself and lady is requested at the Opening and Ball, at the Bath Hotel, Bath, Pa. on Thursday evening, June twenty-eighth, Eighteen hundred and ninety-four. Respectfully Yours, Alfred Jones, Proprietor.

This 1894 invite to a ball at the Bath Hotel is printed on heavy ivory paper. A beautiful cover with an embossed lady's head folds over the printing. The good food, dancing, and merry times at the hotel became the subject of a poem written in the 1800s. People from Easton, Bethlehem, and Allentown often came for an evening's entertainment. Another ball was the Shang High Ball on March 15, 1855. Its organizing committee was James Vliet, Daniel Siegfried, Dr. G. P. Kern, Reuben Hirst, John Barnes, and Dr. P. B. Breinig; floor managers were Stephen and Jacob Hirst, and music was by Stephen Hartzell. The cost to attend was $2.50. (Bath Museum.)

This letter, written in 1906 on Bath Hotel stationery, is from Irvin Metz to his wife, Bessie. Irvin worked for the railroad and had been transferred to Bath. He stayed at the hotel while searching for a place for them to live. He writes the town is "handy" and that he has found a nice place for them to rent. She joined him in Bath and they lived for many years in the former Daniel Steckel Sr. house on Northampton Street. (Elizabeth Fields.)

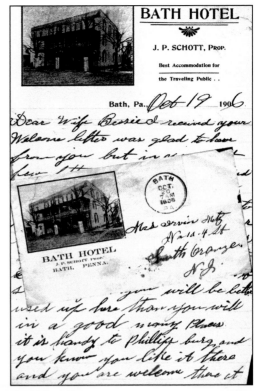

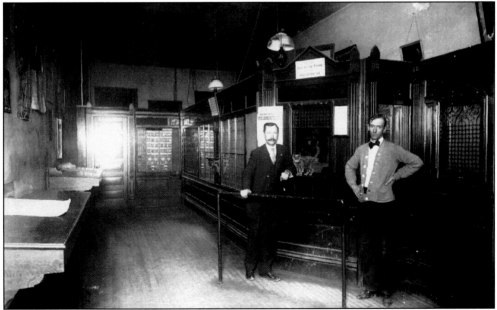

The first post office in Bath was established in 1815 with Jacob Vogel as postmaster. The total proceeds from the first year were $11.44. This photograph was taken when the post office was in the left side of the bank building, built in 1903, at 107 East Main Street. On the left is Asa Beers, postmaster from 1897 to 1914, with his clerk John Remaly. The sign above them reads, "Do not spit on the floor, to do so may spread disease." (Bath Museum.)

This brick Victorian house at 216 North Chestnut Street was built in 1870. The original cast-iron fence, elaborate porch, double front doors, and pull doorbell still exist. The barn on the right was torn down in 1972. (Dianne Kmieczak [née Kist].)

The silk mill was built at 150 North Chestnut Street in 1897. This postcard shows Chestnut Street, a dirt road, looking south into town. The two-story brick building on the left is the silk mill. One can see Christ Church in the distance. The cost to build the mill was $16,000, and it had steam heat and electric lights. It burned in the early 1920s. Bath also had an 1887 brick knitting mill owned by William and Daniel Odenwelder where cotton, woolen, worsted, and silk seamless hosiery were made. It employed 100 people. It was opposite the railroad station and still stands on the south side of West Barber Street. (Darrell Mengel.)

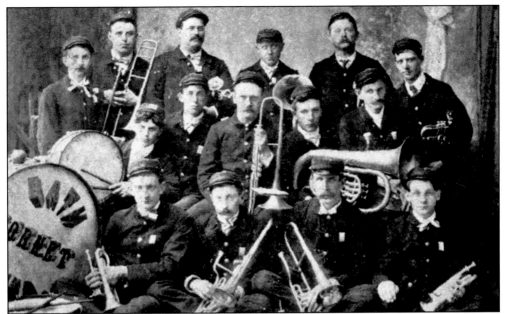

The first brass band was organized in Bath in 1824. The sixth band, the coronet band pictured here, was organized in 1897 by James Bartholomew. Members are, from left to right, (first row) Charles Scholl Sr., Asa Beers, Thomas Dech, and Percy Johnson; (second row) Raymond Fatzinger, Rube Douglas, John Barrall, Howard Bartholomew, and George Beers; (third row) John Beers, Milt Hoch, unidentified, John Schaffer, James Bartholomew (conductor), and Alfred Satzinger. The Bartholomews led three of the bands and played at many concerts throughout the eastern United States. (Bath Museum.)

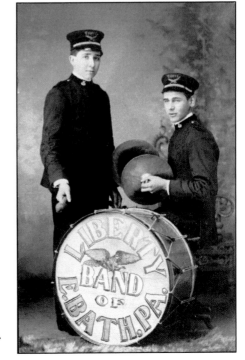

Benjamin J. Eberly founded the seventh band, called the Liberty Band of East Bath, Pennsylvania. Pictured are George Rundle (left) and Floyd Dech in 1914. In the early 1900s, Bath was growing so quickly that many were convinced East Bath constituted a separate town. (Gordon Bartholomew.)

Opening

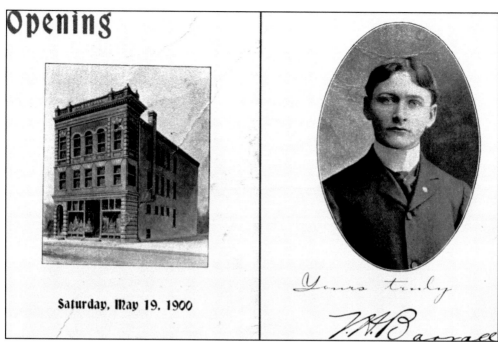

Saturday, May 19, 1900

Yours truly

In 1900, Victor Barrall, age 20, opened a new store at 137 South Chestnut Street. A picture of the building and gold lettering graced the cover (above left) of his invitation, and his picture (above right) and the text were inside. The opening of the store included a concert from 8:00 p.m. to 10:00 p.m., probably by the Bath Coronet Band. Barrall died an early death from tuberculosis, but the business continued in the same building run by one of his clerks and friend, Benjamin Rohn. Below is a picture of the B. F. Rohn store windows. The building remains the newest building on South Chestnut Street. (Bath Museum.)

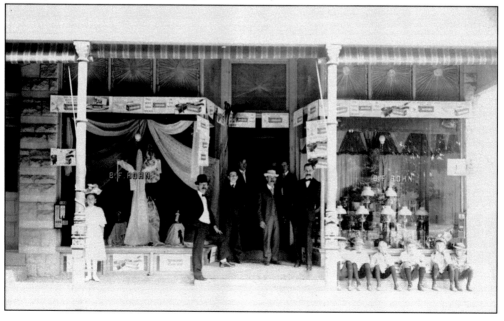

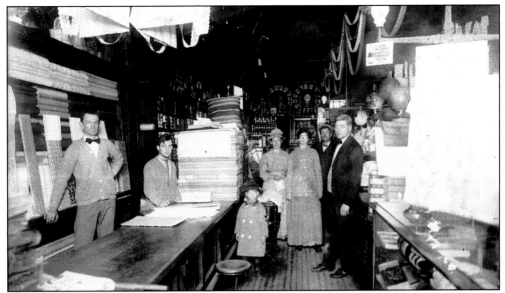

This is a photograph of the interior of Rohn's grocery store. Standing at left is Benjamin Rohn. There are bolts of fabric to the left and a row of gone-with-the-wind lamps on the right. The second floor of the store housed the telephone switchboard, with some of the party lines including more than 15 homes. In Bath in the early 1900s, there were at least three grocery stores, one green grocery, three meat markets, one shoe store, two jewelers, three barbers, one hardware store, two bakeries, two undertakers, three doctors, one livery stable, and one carriage works. (Bath Museum.)

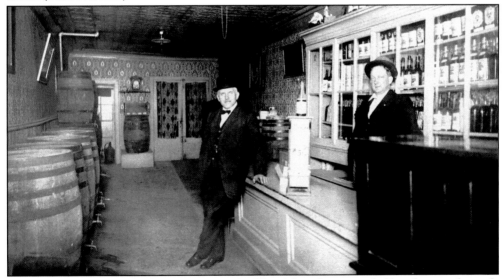

This is the interior of the liquor store at 124 West Main Street, probably taken in the early 1920s. Owner Charles S. Scholl is behind the counter. Before Scholl, it was run by E. and Wm. Martens. The building and tin ceiling still exist. Whiskey, other liquors, and wine was shipped by rail in barrels and then transferred into crocks and bottles at the store. Peter Steckel had a distillery, built in 1844 as a mill, at the north end of town. He worked 100 bushels of corn or rye a day, averaging four gallons of whiskey per bushel. His whiskey was mixed with turpentine and used for illumination until coal oil was discovered. (Bath Museum.)

Lewis W. and Annie Siegfried built this house (above) at 369 West Main Street in the late 1800s. The property wraps around the Siegfried cemetery and had a small barn. Behind the house is a high knoll called Siegfried's Hill where one can see the gap in the mountains and the towns of Nazareth and Bethlehem. Lewis served on council for 16 years and ran for tax collector in 1929 with a pledge "If elected I will donate $100 per term toward a swimming pool." Lewis and Melvin Siegfried are standing (below, left to right) with horses Maude and Kitty. (Above, GWHS Museum; below, Bath Museum.)

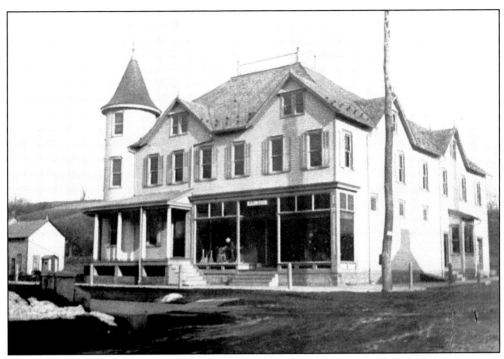

The Edgar A. Graver store (above) was built in 1905 on the northeast corner of Chestnut and Northampton Streets. Mount Wolf is behind it in the distance. It was a grocery store that had a full line, including large wheels of cheese under glass and many varieties of cookies displayed in glass-covered boxes, and sold by the pound eggs and homemade and creamery butter. Later it became a slip factory, Kist's Karpet, the Hutch, and, at present, apartments. The salt brick advertisement (right) is the front and back cover of a booklet of blank pages that Graver gave to his clients. (Bath Museum.)

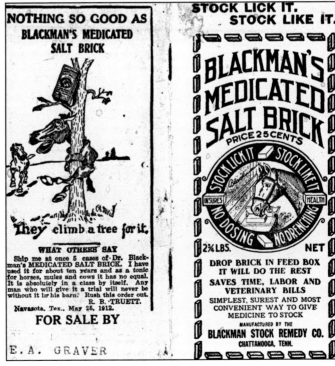

NOTHING SO GOOD AS
BLACKMAN'S MEDICATED
SALT BRICK

They climb a tree for it.

WHAT OTHERS SAY
Ship me at once 5 cases of Dr. Blackman's MEDICATED SALT BRICK. I have used it for about ten years and as a tonic for horses, mules and cows it has no equal. It is absolutely in a class by itself. Any man who will give it a trial will never be without it in his barn. Rush this order out.
R. B. TRUETT.
Navasota, Tex., May 25, 1912.

FOR SALE BY

E. A. GRAVER

STOCK LICK IT.
STOCK LIKE IT.

BLACKMAN'S
MEDICATED
SALT BRICK
PRICE 25 CENTS

STOCK LICK IT STOCK LIKE IT
INSURES HEALTH
NO DOSING NO DRENCHING

2¾ LBS. NET

DROP BRICK IN FEED BOX
IT WILL DO THE REST
SAVES TIME, LABOR AND
VETERINARY BILLS
SIMPLEST, SUREST AND MOST
CONVENIENT WAY TO GIVE
MEDICINE TO STOCK
MANUFACTURED BY THE
BLACKMAN STOCK REMEDY CO.
CHATTANOOGA, TENN.

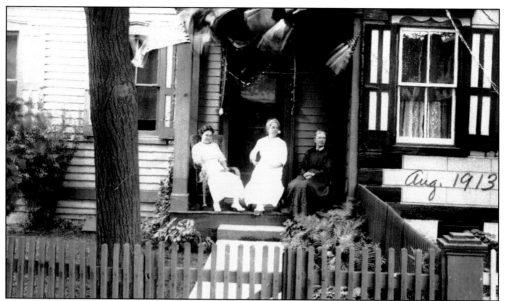

It is August 1913, at 235 West Main Street. Seated from left to right are Flora B. Guth (née Mauser), Annie Fehnel (née Miller), and Susan Miller (née Beck). Flora and her husband, Harry, lived in the attached house on the right, along with three generations of the family. Harry had an ice business where he cut ice from the Siegfried dam in the winter, stored it in the icehouse between layers of sawdust, and went door-to-door in the summer and chiseled or sawed off 15¢ or 25¢ pieces. Later they moved to 210 Washington Street and ran the ice business there. Note the Guths' home had wide wooden siding designed to look like cut stone. Both were demolished in 2005. (Ann Bartholomew.)

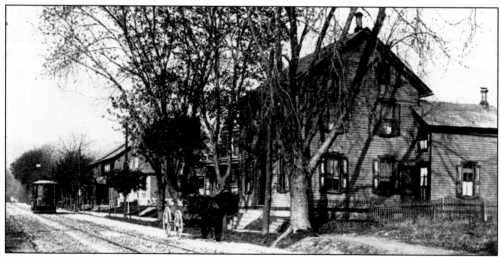

The Bath-Nazareth trolley ran from 1908 to 1927. It started at the square and followed Main Street, Broadway (now Broad Street), and the Nazareth Pike to the railroad tracks leading into the Penn-Allen Cement plant. Penn-Allen would not allow the trolley to cross its right-of-way, so passengers had to disembark and get on a second trolley to finish the journey. The trolleys left every half hour. This postcard shows the trolley on Main Street looking toward the square. Note the horse and wagon in front of 285 East Main Street. Both sides of the dirt street had hitching posts for horses. (Bath Museum.)

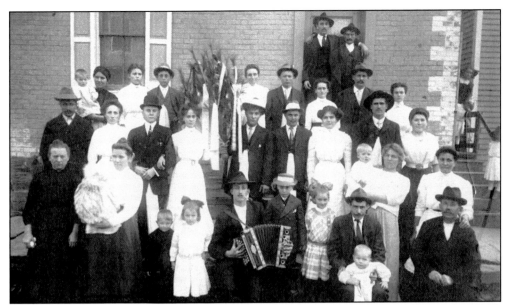

This is a photograph of immigrants gathered for a 1911 May Day celebration. The painted brick building behind them is 100 South Chestnut Street. On the right is a frame barn used as a temporary place of worship by the Catholics and as a movie theater until it blew over in a storm. In the second row (right), the woman holding a baby is Regina Marschang holding son Martin, and Mr. Bogarosh is seated with his wife behind him (far right). In the middle row from left to right are unidentified, unidentified, Chris Muschler, Mrs. Stephen Gunther, Stephen Gunther, Mr. Yost, and Mrs. Yost. In the back row, the fourth person from the left is Julia Moser (wife of Wendell Moser), and the seventh is Martin Brandl. Standing in the doorway at left is Michael Marschang. (Bath Museum.)

These purple martin birdhouses stood 10 feet high in the backyard of 126 West Main Street. Bathites have shown their love of nature in many ways over the years. One birdhouse was moved to Carl Rehrig Park on Mount Wolf. (Catherine Zakos.)

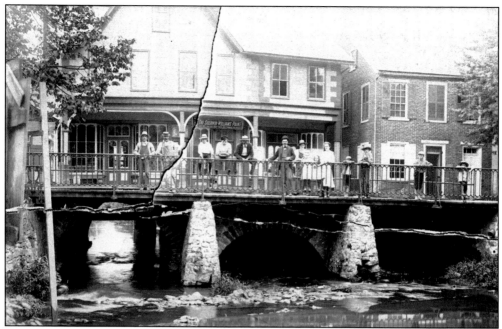

Bath was named after Bath, England, and these West Main Street stores mimic shops over the water in England. From left to right, there was an ice-cream parlor and paint and hardware store. The people in this rare photograph are, from left to right, Robert ?, Paul Meyers, Edward Moser, William Barrall, Asa McIlhaney, Alfred Whitesell, unidentified, Hilda Beers, Ethel Schafer, Ruth McIlhaney, Harry Silfies, Robert Silfies, Chester Sherer, and Bertram McIlhaney. The stores were torn down after the 1945 flood, but the brick house (right) at 224 West Main still stands. (GWHS Museum.)

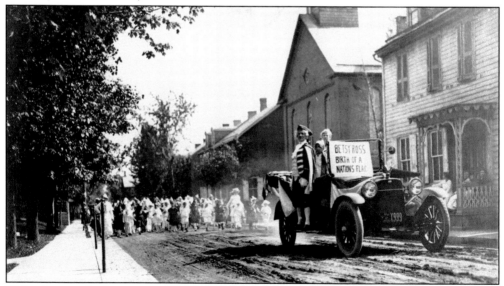

This photograph shows a parade coming north on South Walnut Street. The sign on the car reads, "Betsy Ross, Birth of Nations Flag." Following is a large group of children. In the background is the Presbyterian church, built in 1870, and the house (no longer standing) just south of the "Old Grey Cottage." (Ruth Himler.)

Three

BATH, THE HUB
1912–1936

In 1912, the logo "The Hub of the Rock-Product Region, Bath, Pa." (upper right) appeared on store receipts, in the newspaper, and in the 175th anniversary book. The spokes of the hub read, "Cement, Slate, Limestone, Water, Trolley, Railways, and Electricity." Bath was the center of Northampton County and the center of commerce in the area. The population of Bath in 1920 was 1,401. The top of the picture shows a portion of a Bath Creamery receipt, and the bottom is the east side of the creamery, formerly Barber's Mill. (Bath Museum.)

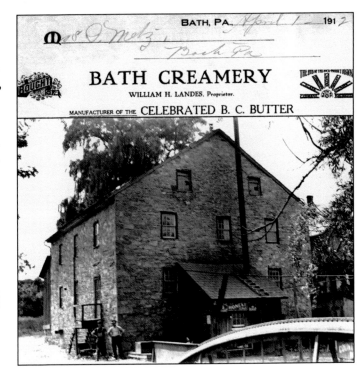

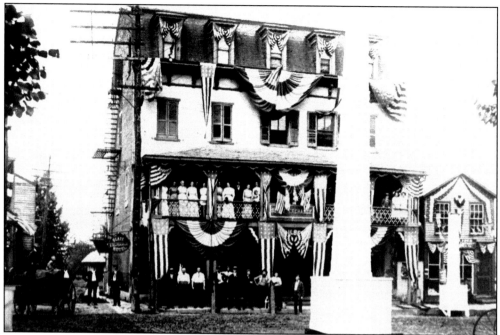

Old Home Week in 1912 was a huge celebration lasting from August 4 to 10. The 15 men on the decorating committee built wooden pylons, shaped like Washington monuments, covered with muslin and decorated with flags. These were placed at regular intervals along both sides of Main and Chestnut Streets. This photograph shows the Slate Exchange Hotel with an extra-large pylon in the center of the square. There were 12 other committees planning other facets of the celebration. (Bath Museum.)

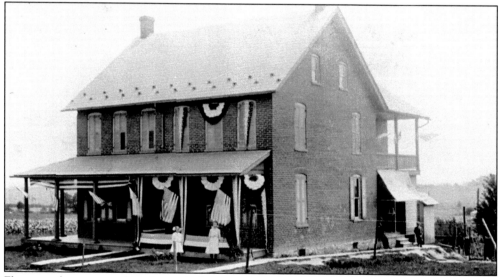

Flags were hung everywhere from windows, porches, and railings. Pictured here from left to right are Mabel Schaffer (née Dotter), Naomi Ritter (née Eberly), unidentified, and Arthur Eberly in front of the house on the southwest corner of Penn and Broad Streets. The house still stands. The anniversary week program had a Religious Day, Industrial Day, Educational Day, Athletic Day, Old Home Day, and Civic Day. (Bath Museum.)

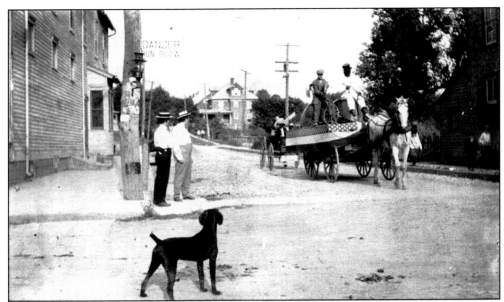

Two men and a dog watch the parade go by at the intersection of Chestnut and Northampton Streets. Edgar A. Graver's store is on the left, and Joseph Steckel's house is on the right. The house in the distance is 118 East Northampton Street. Above the men is a sign that reads, "Danger Run Slow." Just below is one of many kerosene lamps that illuminated the sidewalks at night. Around 1900, Emmanuel Siegfried, a policeman, had as one of his responsibilities to care for the lamps. Just before nightfall, he made his rounds with a little ladder and lit each one. (Bath Museum.)

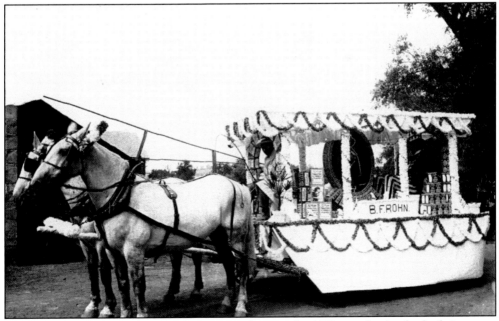

This photograph shows the B. F. Rohn store float in the 1912 parade. At the back is a man dressed as Uncle Sam. He is surrounded by pyramids and arches created from grocery boxes and cans. (Bath Museum.)

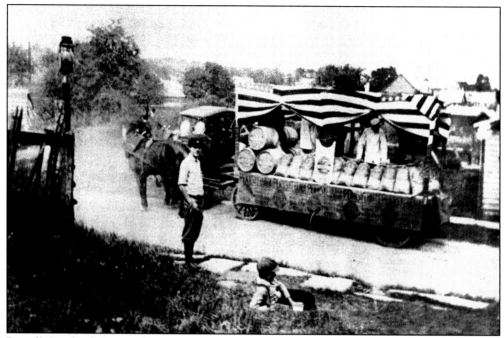

Russell Siegfried Sr. stands waiting for the float covered with bags of potatoes and kegs of an unknown beverage to pull out. Note the kerosene lamp on the pole at left. For the 175th celebration, several sets of commemorative postcards were printed. Some postcards were street views and others documented historic buildings. (Bath Museum.)

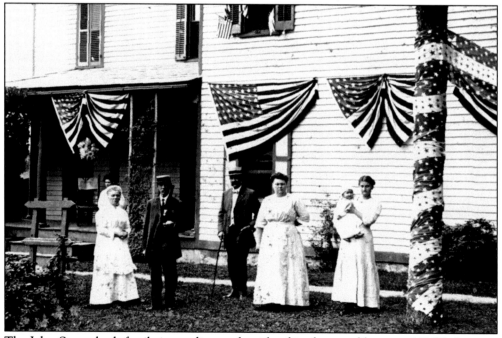

The John Sensenbach family is standing at the side of its decorated home at 142 Washington Street. John had a shoe store on West Main Street. On the right is Amelia Sensenbach holding Elizabeth. (Bath Museum.)

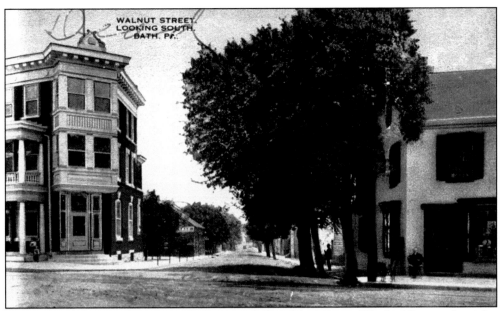

The postcard shows Walnut Street looking south from Main Street. The building on the right, 100 West Main Street, was J. P. Snyder's Haberdashery. Later the post office moved from the bank to this location. The side of the building is angled to follow the line of Walnut Street. This building still stands. (Bath Museum.)

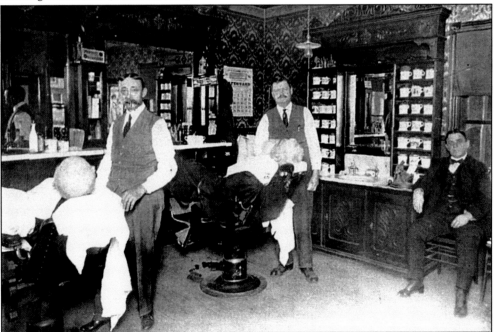

This is the interior of Frank Sensenbach's barber shop. The shop was on West Main Street between the Bath Hotel and the Monocacy Creek. Note all the shaving mugs on the shelves to the right. Many men kept their personal mug at the shop. The shop is probably most famous for floating across Main Street during the 1945 flood without breaking a bottle or mug. It was returned to its position and remained there for another 25 years. (Bath Museum.)

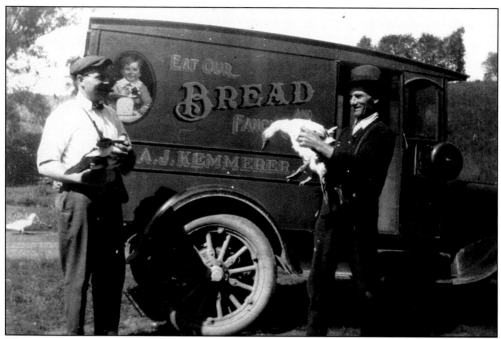

The photograph above shows Albert "A. J." Kemmerer (left) and one of his employees in front of his bakery truck. What they are doing with the ducks is anyone's guess. Note both have money purses. A. J. Kemmerer and his wife, Gertrude, opened their first bakery at 102 West Main Street. In 1915, they moved to 140 East Main Street and had a large store and bakery in the backyard. They stopped baking when their son Albert R. went to serve in World War II, but continued selling groceries until 1967. The building was later converted to a garment factory. The photograph below shows the interior of Kemmerer's store with A. J. standing on the far right. A. J. was the chief burgess (mayor) of Bath from 1934 to 1949. (Above, Larry Kemmerer; below, Ruth Himler.)

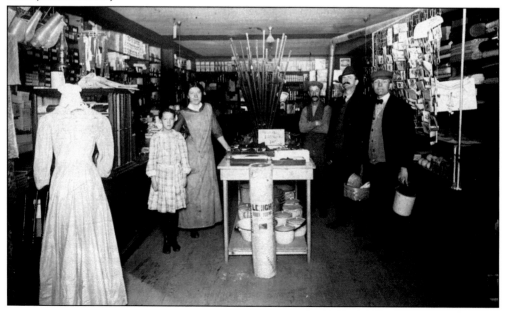

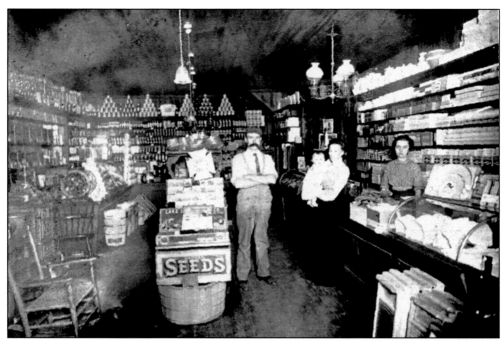

The Lewis Hahn General Store was located on the northeast corner of Washington and Penn Streets. From left to right are Lewis Hahn, wife Florence holding baby Ella, and clerk Hattie Eberly (née Deemer). Molasses was sold by the quart from big barrels, but customers had to bring their own containers. When it got to the bottom, the thick sugar that had settled was sold by the pound. (Catherine Hahn.)

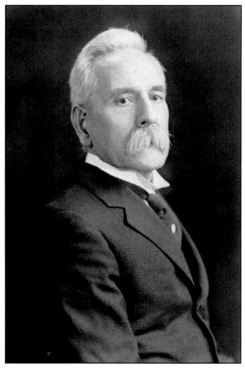

This is a portrait of R. W. "Pappy" Barnstead. He was the editor and publisher of the *Bath News* until 1917. In addition to news and advertisements, the newspaper discussed people's Sunday visits and vacations. (Bath Museum.)

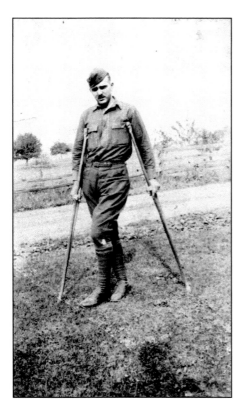

In 1918, Charles H. Unangst returned from World War I on crutches. He was in Company C 310 Machine Gun Battalion A.E.F. Seventy men from the Bath area served in World War I. After the war, Charles served as Northampton County commissioner for many years. (Bath Museum.)

Ann Machalgyk, age 3, is standing in front of the World War I monument at the corner of Penn and Washington Streets. Salem's Church, built in 1870, at 221 Penn Street can be seen in the background to the right. The monument was later moved to the legion on Race Street. (Ann Bartholomew.)

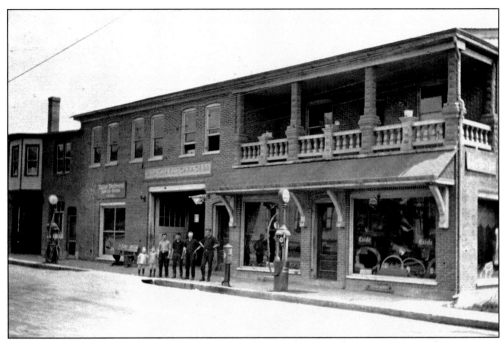

Frank Michael's garage was built in 1915. In 1932, it became the George H. Rehrig Garage. The people in this 1924 photograph, from left to right, are George G. Rehrig, Carl Rehrig, Earl Michael, Dewey Lilly, George H. "Pappy" Rehrig, and Floyd Dech. A Michael's Garage receipt dated 1929 shows a car inspection was 50¢ and five quarts of oil was $1. (Bath Museum.)

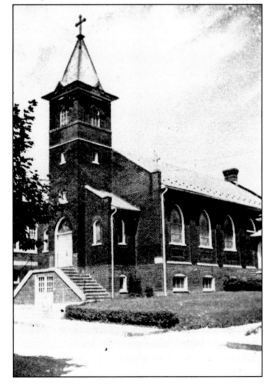

The Sacred Heart Church on Washington Street was built in 1922. This photograph was taken before the front was expanded in 1953. In 1920, Bessie O'Reehil Metz wrote to the archbishop of Philadelphia asking for information on how to start a Catholic diocese in Bath. While the church was being built, the congregation held services in the frame building at the rear of 100 South Chestnut Street. (Josef Guenther.)

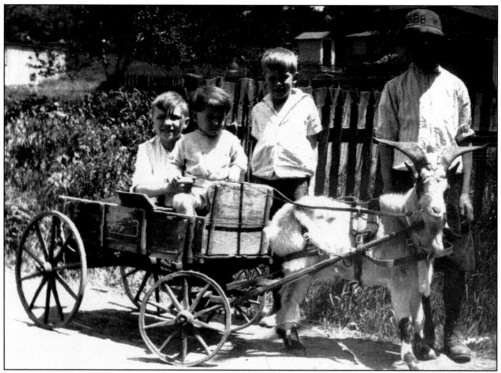

It is June 1914 and four children are taking turns riding in a goat cart in the back yard behind Christ Church on Chestnut Street. From left to right, the children are twins Reginald and Randy Hellfrich, Garrett Miller, and Harry Miller Jr. Reginald later became a minister and was ordained in Christ Church by his father, William, who had served as its pastor for 35 years. (Bath Museum.)

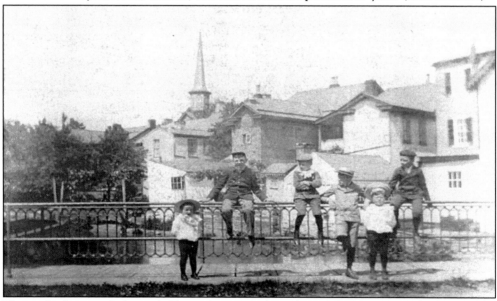

This early photograph shows children relaxing on the railing of the Main Street bridge over the Monocacy Creek. Behind them are the backs of all the houses on the west side of South Chestnut Street, and one can see the steeple of Christ Church across the street. (Bath Museum.)

Boy Scouts Leo Bittenbender (left) and Ray Ervin pose for this picture in 1920. The first troop in Bath was organized in 1917 by J. Douglas Mitchell and Eckley E. Patch. (Mary Ellen Bittenbender.)

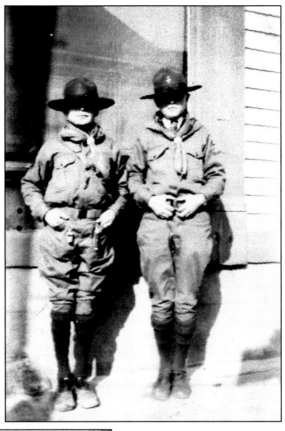

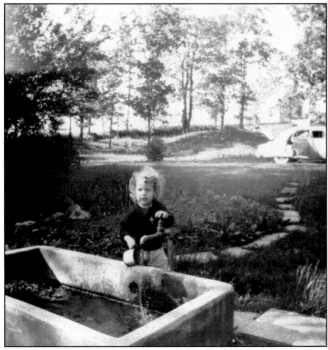

This photograph shows Sharon Bittenbender, age 5, getting a cup of water from the trough at Sleepy Hollow Spring. In the early 1900s, Walnut Street ended at Northampton Street and a footpath led to Sleepy Hollow on the north side of Mount Wolf. It was a woodland retreat to explore and escape the summer's heat, it was a place for church picnics, it was a hill climb for boys with Indian motorcycles, and it had a shanty to play cards in until the wee hours of the morning. (Virginia Bittenbender.)

Samuel Miller's drugstore was on the northwest corner of Main and Walnut Streets facing south. The sign on the right of the window reads ,"Kow-Kure, For Cows Only, A Medicine Not a Food." Another reads, "Save the Tags, Spearhead Plug Tobacco." The bottle-shaped sign to the left of the window reads, "S.R. Miller, Bath." The small diamond-shaped sign on the tree reads, "Chew Big Four Tobacco." Note the rear section of the building was built on an angle to follow the angle of Walnut Street. This brick building and three others adjacent to it were torn down in the late 1950s. (Bath Museum.)

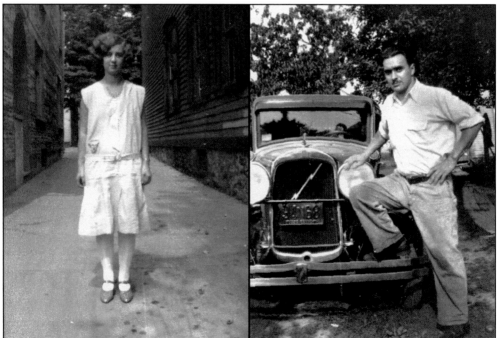

Meet the Hartzells. Husband and wife, Kermit Hartzell and Mary Baltz Hartzell owned Hartzell's Luncheonette at 110 West Main Street. They posed for these pictures in 1930, Mary in the alley next to their store and Kermit with his car. (Bath Museum.)

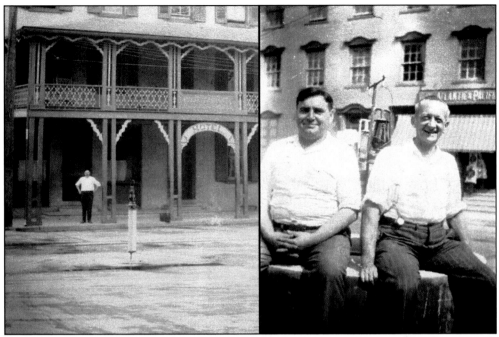

With the advent of the automobile, a need was felt for better traffic control in the square. It started with a single pole with a kerosene lantern on top (upper left.) In the 1930s, it became a round concrete base with an iron pole with two arms and two kerosene lanterns (upper right). Seated in the middle of the square, from left to right, are Stephen Zakos, owner of the Slate Exchange Hotel, and Charles Scholl, owner of the ice-cream parlor. Note the A&P (formerly Musselman's Jewelry Store) in the background. The final attempt was the cement and traffic light combination (below.) None of these ideas proved to be successful, and by the late 1930s, they went back to nothing in the square. (Catherine Zakos.)

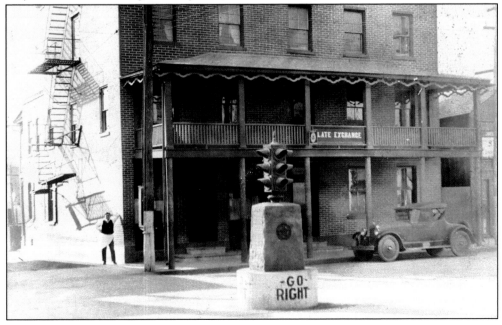

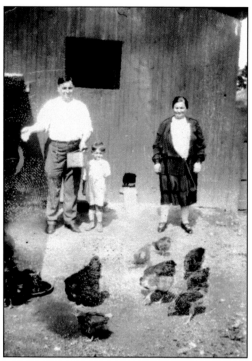

In 1929, Stephen Zakos and his wife Fanny came to Bath and purchased the Slate Exchange Hotel. Behind the hotel, they raised chickens and sheep. Pictured, from left to right, are Stephen, Rudy, and Fanny Zakos. (Catherine Zakos.)

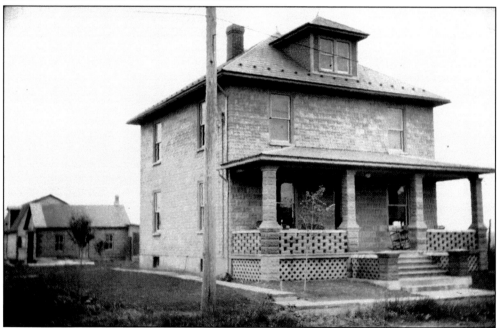

This is the Robert F. Laubach house at 275 Broad Street. This house and many others in Bath were built with cement blocks that his company manufactured in the factory at the rear of 267 Broad Street. The men poured concrete into forms and tamped to remove air pockets. Laubach was born in 1882 and educated through fourth grade. In addition to making blocks, he also designed and drew houses. His business flourished in the early 1900s, and at its height, he had 10 to 15 employees. The typical cost of a block home was $5,500. (Bath Museum.)

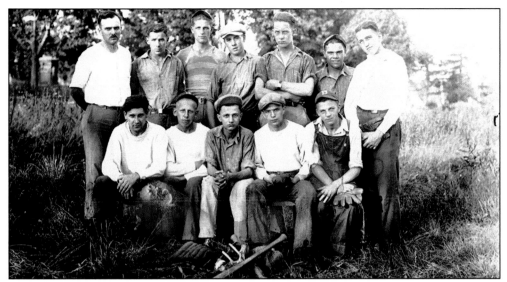

This is a photograph of one of the Bath baseball teams, probably from the early 1930s. Note the B on some of their caps. They are, from left to right, (first row) John Spanitz, Leon "Lemon" Bartholomew, Allen Shiffer, Phillip Doroskio, and Archie Leigh; (second row) coach Charles Unangst, Malcom Smith, Harry Frey, Bill Mooney, Bill Krause, Wellington Sterner, and Richard Leiby. The baseball diamond was in the northeast field behind Penn and Washington Streets. This was also the field that was used for summer carnivals and community events. (Catherine Zakos.)

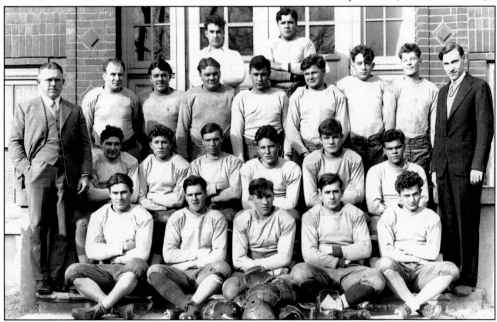

This is the 1936 Bath AA football team. They are, from left to right, (first row) Bill Santo, George Bittenbender, Frank "Fatty" Suranofsky, John Santo, and Allen Shiffer; (second row) coach Harry "Buck" Weaver, John Spanitz, Fred Shunk, Miles Williams, Bob Harding, Sam Barrall, Wellington Stermer, and manager Irvin Metz; (third row) Steve Grutski, Norman Ruth, Chris Manning, Earl Garland, Frank Sensenbach, Bill Krause, and Dick Nissley; (fourth row) Dick Bourguignon and Charles Sziagyi. (Pauline Werner.)

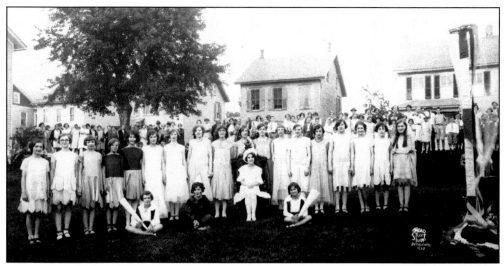

This 1930 May Day celebration photograph was taken on John Sensenbach's lawn at 142 Washington Street. From left to right, the girls are (first row) Eleanor Leigh, Eleanor Haidle, Queen Nettie Edelman, and Mary Horn; (second row) Mildred Mehrkam, Lillian Haupt, Margaret Moser, Catherine Leigh, Bernetta Hayne, Adeline Graybill, Ruth Nissley, Margaret Kunkle, Sophie Barrall, Mickey Wagner, Grace Graver, Dorothy Gish, Pauline Hartzell, Hattie Hahn, Verna Harding, Elizabeth Frey, Eleanor Saras, and Elizabeth Schaffer. Note the maypole on right. (Bath Museum.)

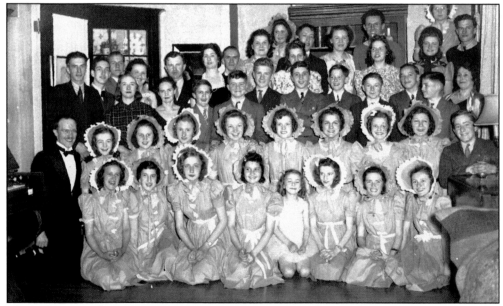

The Sunbonnet Girl was a comic operetta in two acts performed in April 1940. This cast picture was taken inside the Christ Church parsonage at 113 South Chestnut Street. Directed by Reg Helffrich (kneeling at left), the operetta had 15 members in the cast and a chorus of 26 boys and girls. There were many plays in town from the 1880s up to 1950 by a variety of groups: churches, drama clubs, and anniversary committees. Some of the productions were *Professor Pepp, In Old Louisiana, Aunt Lucia, Windmills of Holland,* and *Me an' Otis.* Beginning as an organist at St. John's Church, Louis Kreidler became a well-known baritone soloist in the country. (Bath Museum.)

Four

WE THE PEOPLE OF BATH
1937–1987

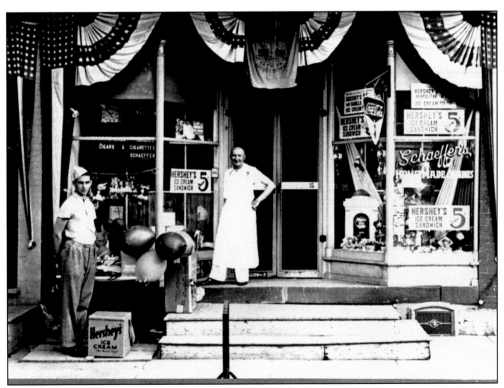

The 200th anniversary of Bath in 1937 was celebrated in grand style. There were anniversary stickers, bronze medals, automobile bumper cards, flags, books, and special editions of the *Bath News*. Lewis Schaeffer (right) is shown on the steps of Schaeffer's Homemade Candies at 120 West Main Street, with Jack Mertz. The blue and gold bicentennial flag designed for the occasion hangs over the door. The population of Bath in 1940 was 1,720. (Bath Museum.)

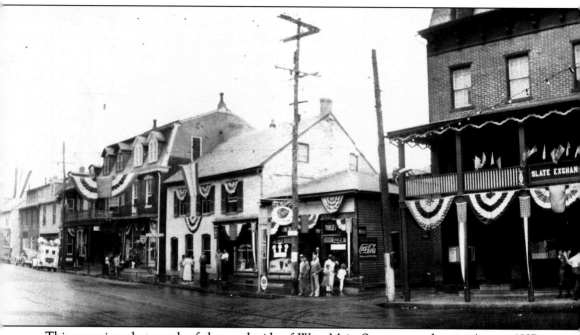

This sweeping photograph of the south side of West Main Street was taken in August 1937. From left to right, the buildings are the old post office, Ebner's Cut Rate Drug Store and soda fountain, a private home, Clarence Graybill's home, Hartzell's Luncheonette, William Barrall's house, a meat market, Alvin Shiffer's home, John Sensenbach's shoe store and Western Union,

For the bicentennial, a historical pageant was written. It had 11 acts and a cast of over 250 people. It required a stage 200 feet in length, which was set up on the baseball grounds behind St. John's Church. Pictured are some of the participants, from left to right, Catherine, Caroline, wife Flossie, Charlotte, and Horace Heller. (Catherine Hahn.)

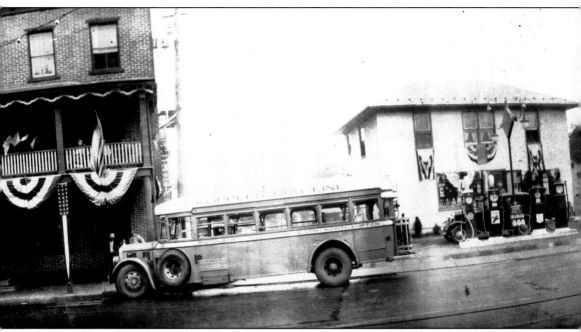

Louie Katz's dry goods store, Lou and Katie Schaeffer's candy store, George Diner's tailor shop, George "Coney" Marten's ice-cream and drugstore, Slate Exchange Hotel, and Bob Scafe's Sunoco station. Note the bus from Klipple's Bus Line, which ran between Bethlehem, Nazareth, Bath, and Northampton. (GWHS Museum.)

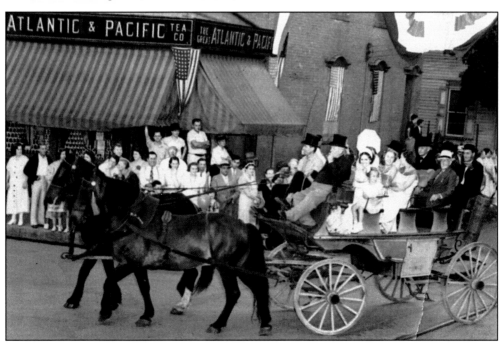

As the 1937 parade rounds the corner in the square, the horse-drawn carriage with the queen of the bicentennial, Helen Abel, can be seen. Parade watching was great from the steps at the corner entrance to the A&P in the background at 145 South Chestnut Street. (Bath Museum.)

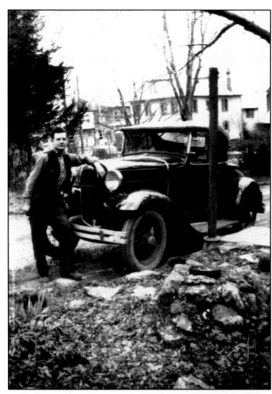

This is a photograph of Leo Bittenbender and his 1930 Ford Roadster on McIlhaney Avenue. George H. Rehrig's garage is visible in the background. (Mary Ellen Bittenbender.)

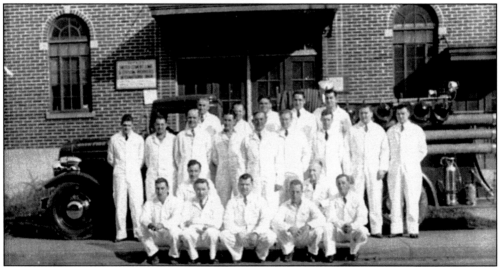

In 1940, the Bath Fire Department purchased a new fire truck. From left to right, the men of the department are (first row) Anthony Klusko, Charles McIlhaney, Irvin Metz, Stewart Weiner, George Silfies, Henry Lawrence, and Horace Hoff; (second row) Donald Siegfried, Richard Bourguignon, Mike Michalgyk, Ernest Hayne, Howard Jones, William Musick, Robert Jones, Norman Shiffer, and Willard Waltz; (third row) Bert McIlhaney, Charles Hutchinson, Willington Stermer, Frank Suranofsky, and Clayton Funk. Members not in the photograph are Rollo Harding, Archie Leigh, and Daniel Siegfried. The Bath Fire Company was formed in 1839. (Bath Museum.)

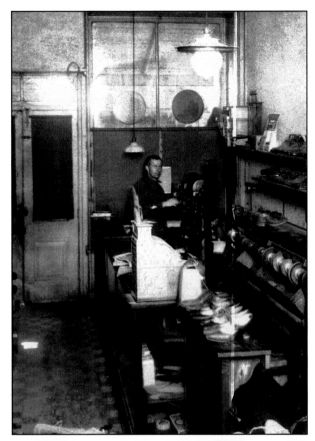

This is Alex Pfeiffer (right) in his shoe store at 133 East Main Street. Originally this store was John Schaffer's bakery with the bake ovens in the backyard. The storefront behind him was later modernized to a single door and store window. In 1945, the window (below) was decorated to welcome home the troops from World War II. There were 240 men and women from the Bath area who served in World War II. The old fire company doors are visible in the adjacent building. (Lori Gilbert.)

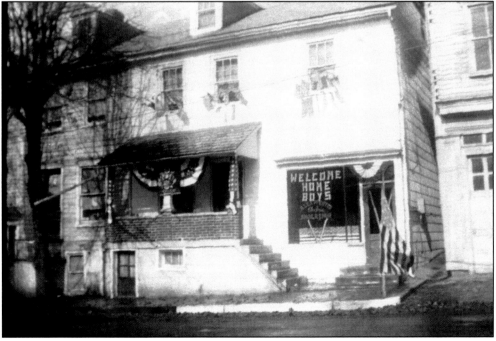

This is a 1946 photograph (left) of H. A. "Yockey" Greene, owner of the *Bath News* for about five years in the late 1930s, and some of the type from his printing shop. His shop was in the barn at the rear of 118 West Main Street, since torn down. The newspaper press was on the first floor, and the smaller presses and typesetting area were on the second floor. The *Bath News* was sold for 2¢ a copy. After Greene, William Halbfoerster Sr. ran the Main Street Press. This 1940 photograph (below) is Halbfoerster inside his stationery store at 118 West Main Street. The third generation of Halbfoersters is still printing the *Home News* today. (Left, Annie and Keith Greene; below, Bath Museum.)

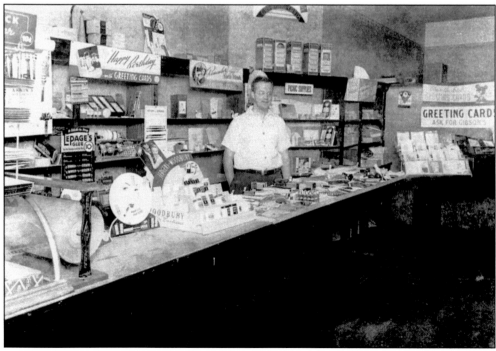

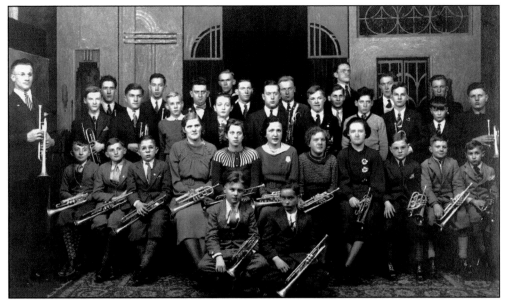

In 1944, Warren J. Schall (left) organized and was the director of Bath's ninth band. He played the trumpet, coronet, and harmonica. He was a slater at Chapman's Quarries and was blind in his left eye from a shooting accident when he was only four years old. Only a few of his students in the picture have been identified: Dorothy Hess, Lillian Laubach, Ray Schall, Wesley Radcliffe, Billy Rothrock, Lester Rinker, and Theodore Heimer. Note the knickers and argyle socks. (Loretta Kotowski.)

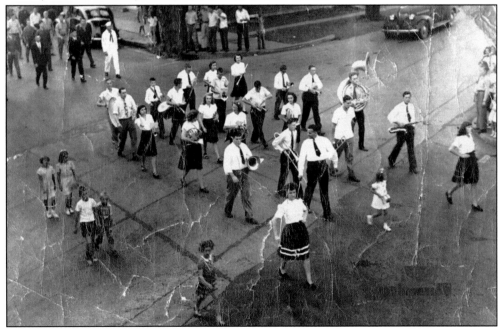

This is a 1945 parade picture of the Bath Band with Warren J. Schall in the lead, taken from the second floor of the American Hotel. The parade is on Main Street passing through the Walnut Street intersection. The three girls in front are, from left to right, Lillian Scheffler (majorette), Loretta Schall (drummer and Warren's daughter), and Charlotte Heller (majorette). (Loretta Kotowski.)

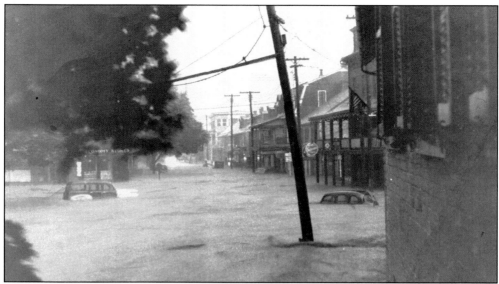

This rare photograph of the square looking east was taken by Gerald Overcash from his second floor window at 226 West Main Street during the July 9, 1945, flood. The water reached the American Hotel, seen in the distance, and flowed down Walnut Street. The station wagon shown floating across the square eventually landed behind the Slate Exchange Hotel (right) in front of the garages. The Sensenbach Barber Shop adjacent to the Bath Hotel floated from the north side of Main Street to the south side next to the Slate Exchange. Siegfried's shanty and Achenbach's coal yard office were also lifted off their foundations on Northampton Street, cars were tossed about like toys, railroad tracks were undermined, and houses were later demolished because of the damage. (Edwin Schall.)

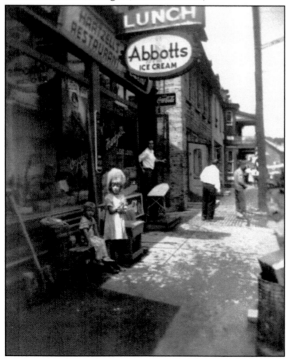

The aftermath of the flood is shown in this photograph of the south side of West Main Street looking toward the square. Kermit Hartzell in the doorway of his luncheonette, children sitting quietly, people standing not knowing where to begin, doors propped open to air out interiors, cans and boxes of garbage at the curb, and a snow shovel to scoop up mud and debris all reflect the enormity of the recovery task ahead. One young boy, Larry Rehrig, who lived in an apartment behind the paint store on the bridge, lost his life. A set of pictures was printed documenting this traumatic event. (Virginia Bittenbender.)

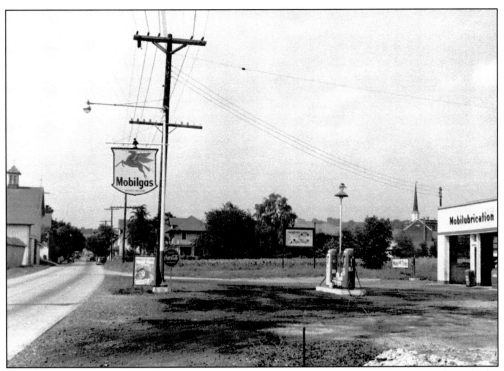

This is a view north up South Walnut Street from the edge of town. Lawrence Alich built the Mobilgas station in 1945. It was demolished in 1988. In the distance, from left to right, one can see Elmer Smoyer's barn, the office and home of Dr. Lionel Cunin and Dr. Nicholas Petruccilli, and the spire of St. John's Church. (Bath Museum.)

This is another view of South Walnut Street, taken in a field to the west. The building in the center is the Martin Smith Chrysler Plymouth Garage, built in 1947 on the east side of South Walnut Street. It still stands although the north show window has been removed. The buildings to the right are Vic's Diner and Victor Heckman's home, which are no longer there. (Mae and Dale Day.)

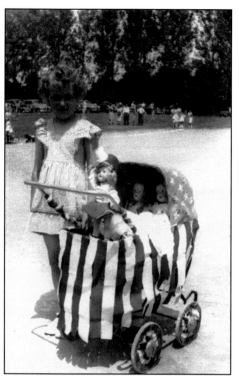

The Fourth of July parade in 1947 had a section for children and their decorated carriages, pets, or bicycles. This is Ann Michalgyk and her entry. (Ann Bartholomew.)

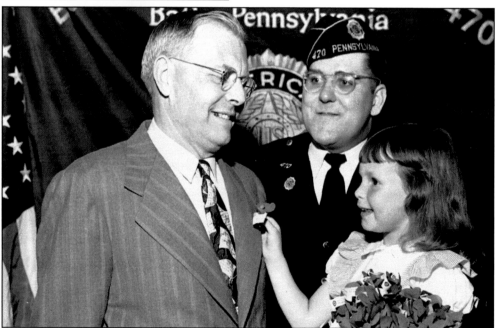

Leona Bittenbender was named Poppy Girl for the Memorial Day festivities in 1948. She is shown here pinning a flower on Chief Burgess A. J. Kemmerer with Donald Mertz looking on. Starting in the 1880s, there have been many celebrations and festivals. In addition to Memorial Day, the Fourth of July, and Old Home Week, there has been Arbor Day, Battalion Day, May Day, and the Green Corn Festival. (Mary Ellen Bittenbender.)

Charles Hahn built this house at 208 North Chestnut Street for his family in 1949. This photograph shows his wife, Catherine, and their daughter Bonnie enjoying a sunny day. In 1949, the house numbers in Bath were reorganized as a result of new house construction. (Catherine Hahn.)

Two young girls standing in the yard of 126 North Chestnut Street pose for this 1926 photograph. The house behind them is the Siegfried home, built by descendants of Joseph Siegfried, one of two brothers that came to Bath in the late 1700s. Note the formal garden beds behind the girls. Chestnut Street, resplendent with trees, plantings, and flowers, was called the "pride of Bath." (Author's collection.)

MANOQUESY BREEZE DRIVE-IN THEATRE

North Chestnut St., BATH
Bath-Klecknersville Highway

Week of May 15th to 21st

Tuesday---"WHEN A MAN'S A MAN"
with GEORGE O'BRIEN

Thurs.---"BILLY THE KID OUTLAWED"
with BOB STEELE

Friday---"WHEN'S YOUR BIRTHDAY"
with JOE E. BROWN

Shorts Comics News

Plenty of Seats and Parking, You Can See the Show from Your Car.

Admission . . Adults--Children 12c
(Tax Included)

Bath had two drive-in theaters. During the late 1940s and early 1950s, one could watch a movie at Frank Haidle's Manoquesy Breeze Drive-In on the west side of North Chestnut Street or at Johnny's Drive-In on the east side of North Walnut Street. (Catherine Zakos.)

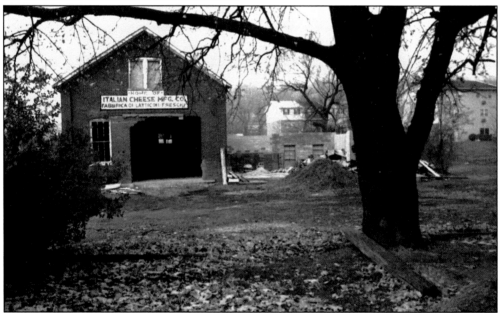

This brick building at 219 West Northampton Street was the cheese factory run by Joe Tito in the 1940s. Around 1927, it was Meyer's Creamery. In this 1979 photograph, Paul Dorwood is starting to renovate the building and add onto the back to make it Paul's Garage. There was a three-story brick chimney on the right that has already been removed. The townhouses on Old Forge Drive are visible in the background. (Author's collection.)

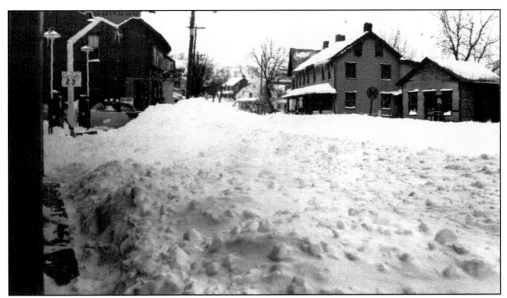

On February 16, 1958, a deep snow blanketed the region. This is a view (above) of the square and west on Main Street from the front porch of the Slate Exchange Hotel. The picture shows the Sensenbach Barber Shop across the street and the adjacent houses (223 to 235 West Main Street) to the left of it, no longer standing. Snowstorms always transport Bath back in time. The pony and sleigh (below) riding through the square in 1958 help foster those old-time feelings. The view is east on Main Street. (Above, Catherine Zakos; below, Bath Museum.)

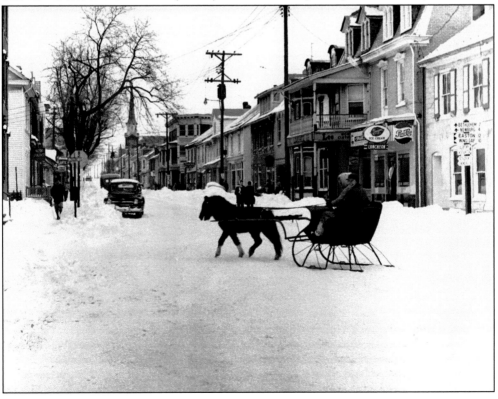

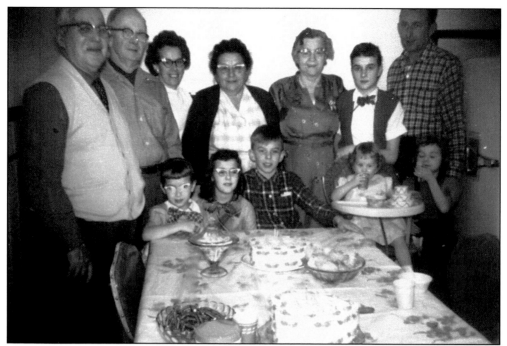

Welcome to Lori Newton's second birthday party. The date is February 4, 1960, and the party is at 133 East Main Street. In attendance are, from left to right, (first row) Kathy and Jamie Wetherhold, Harold Newton Jr., Lori Newton, and Jodie Newton; (second row) Harry Newton, Alex Pfeiffer, Dorothy Wetherhold, Anna Pfeiffer, Hilda Newton, Sally Wetherhold, and George Pfeiffer. Lori must have been a very good girl because the picture shows two cakes plus her own personal three-tier cake on the highchair tray. (Lori Gilbert.)

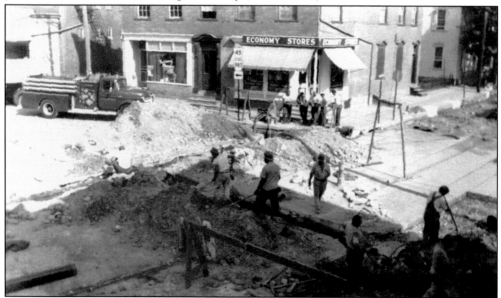

The installation of the sanitary sewer main occurred in October 1959. The men dug the trenches by hand. This photograph of the square and the men at work was taken from the second floor porch of the Slate Exchange Hotel. (Catherine Zakos.)

At Christmas in 1960, this is how the fireplace mantel was decorated in the living room on the second floor in the Slate Exchange Hotel. Because most of Bath dates to the 1800s, almost every building has several fireplaces and wonderful mantels. (Catherine Zakos.)

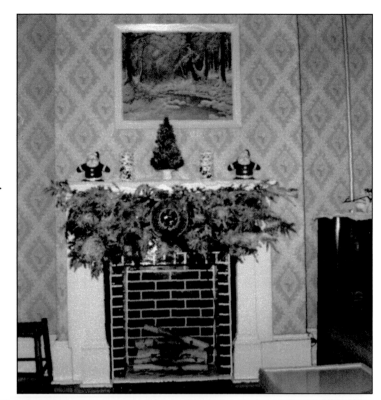

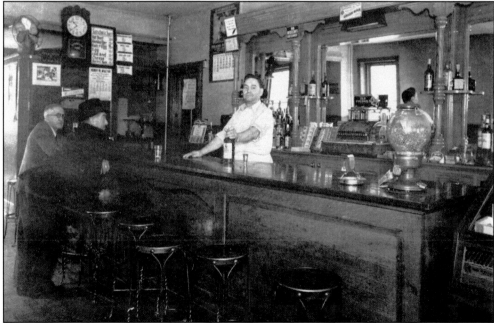

This 1930s photograph shows the interior of the bar of the Slate Exchange Hotel. Owner Stephen Zakos is behind the bar about to serve a shot. On the bar at the right is a penny peanut machine. On the far right is a case of cigars. The menu board offers a hot beef sandwich for 20¢ and a hamburger for 15¢. (Catherine Zakos.)

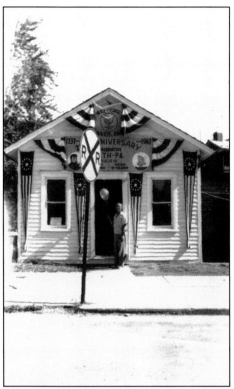

Earl Spengler's old barbershop (formerly Sensenbach's) on West Main Street was used as the Brothers of the Brush headquarters for the 225th anniversary celebration in August 1962. Note the special anniversary flags overhead. (Catherine Zakos.)

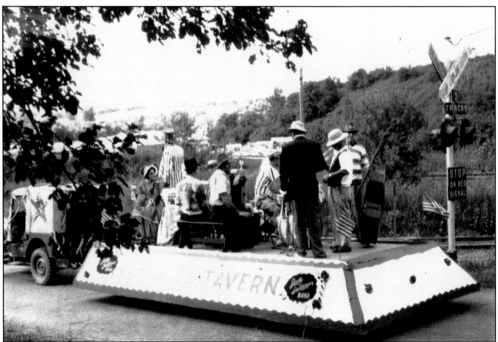

This photograph shows the Joe Nickles Tavern float lining up for the 225th anniversary parade. Joe Nickles Tavern is now the Oaks at Penn and Broad Streets. The float featured a local band. (Doris Burritt.)

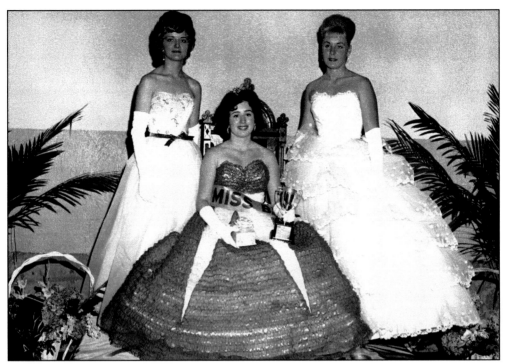

No anniversary would be complete without a Miss Bath competition. The winner and runners-up are, from left to right, Sue Kleppinger, Jeanette DeCarlo (Miss Bath 1962), and Arlene Hummel. (GWHS Museum.)

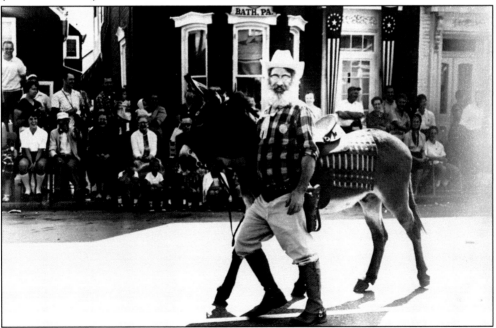

Prospector Sterling "Grolly" Graver shows off his beard and his donkey in the 225th anniversary parade. Thousands of people lined the streets to see the procession. The brick house at 118 East Main Street is in the background. (Pauline Werner.)

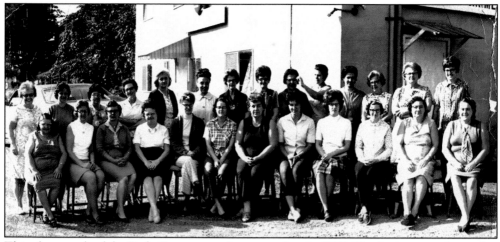

This photograph of the Bath Garment workers was taken in 1970. The business was located at the north end of town along the west side of Route 512 (Walnut Street). Only two women are identified in the picture; in the first row, second from left, is Agnes Rice and on the far right of the first row is Maryjane Gondek. (Doris Burritt.)

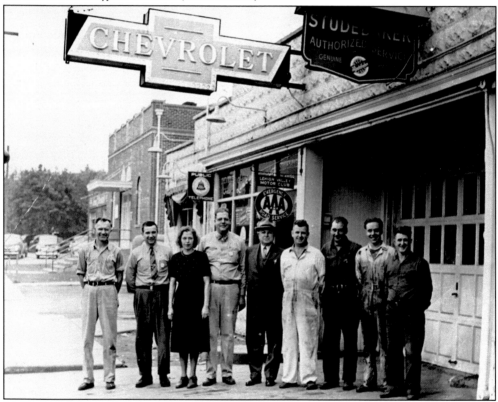

Lambert's Garage stood next to the fire company on the east side of North Walnut Street. Pictured are, from left to right, Willis Wagner, Willard Waltz, Mildred Ackerman, Roy Ackerman, Authur S. Lambert (owner), Stewart Weiner, Clark Bond, Lloyd Hummel, and Sterling Graver. Behind the garage, note the front of the fire company and the Bath Hardware Store, which burned in 1979. The building was later used as a furniture factory. (Robert Graver.)

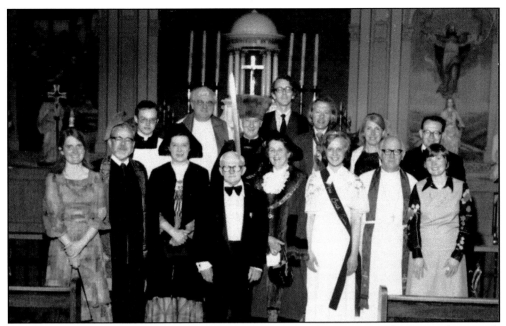

In 1976, the mayor of Bath, England, came over for a visit to the sister city. This group photograph was taken inside Sacred Heart Church on Washington Street. The people in the front row from left are Rev. John Reese (second); mayor of Bath, Pennsylvania, Archie Leigh (fourth); the mayor of Bath, England (fifth); Miss Bath Area (sixth); and Rev. Robert Laubach (seventh). (Elizabeth Fields.)

In 1987, Bath celebrated its 250th anniversary. Part of the weeklong festivities was the "jail" set up by the fire company on Walnut Street. Bathites in jail are, from left to right, Paul Kahler, Dennis Silfies, Dave ?, and Anna Kish. The jail even came equipped with a toilet, but not a lot of privacy! (Josef Guenther.)

This is a picture of a float coming west on Northampton Street. It is a log cabin with thatched roof built by the Slate Exchange Hotel. In the background are the houses at 121 and 125 East Northampton Street. (Virginia Bittenbender.)

This parade picture captures Elias Spengler, Esq., riding on the back of a truck towing a model of the Wolf Academy. The model was built by members of the Governor Wolf Historical Society (GWHS). Spengler was president of the GWHS and the Bath Area Historical Society and was a noted local historian. In 1958, Spengler spearheaded the movement incorporating the Wolf Academy Restoration Society that purchased the academy and began its restoration. (GWHS Museum.)

Five

NORTH

CHAPMAN, CROSSROADS, KLECKNERSVILLE, POINT PHILLIPS, AND COPELLA

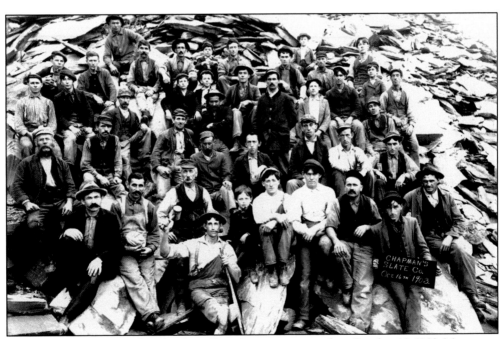

These are the workers of the Chapman Slate Company, pictured on October 16, 1903. Many were immigrants from Wales and England whose wages went toward paying off the cost of their passage to America. It was common for fathers to bring their sons, as young as 10 or 12, to work as "hollobobbers" to sort out small slates and work them into smaller sizes of cleanup rubbish slate. They were not paid personally, but extra was added to the father's pay. In front are Wilson Herberling (holding a raised mallet) and George "Snap" Herbst (holding the sign). (Joseph George.)

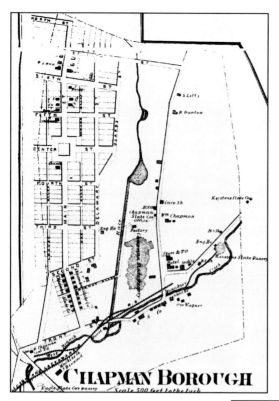

Chapman Borough lies two and a half miles north of Bath. William Chapman purchased this site in 1842 for $1 and a pint of gin according to legend. The Chapman Slate Company laid out the borough, including company housing and a store, hotel, school, stable, and church. The town square on Center Street was never built. Later the quarry was expanded to the west and the excess material was deposited on the site of the company housing. This 1874 map was published by A. Pomeroy and Company in Philadelphia.

The Chapman Slate Company, incorporated in 1864, produced high-quality roofing slate, blackboards, billiard tables, and flagging. Bert Herd is shown in this picture splitting the block, which has been plugged in half. The man to the right is Bill Ducey. (Laura George.)

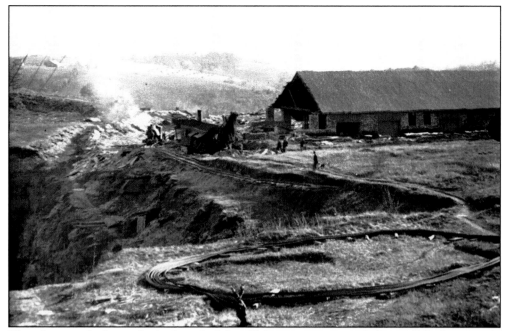

This photograph shows the back end of the old factory or structural slate mill, looking south. The stack was on the right end of the building. This is where baseboards, sills, and blackboards were made. This building was torn down when the quarry was extended, but the stack is still standing. (Joseph George.)

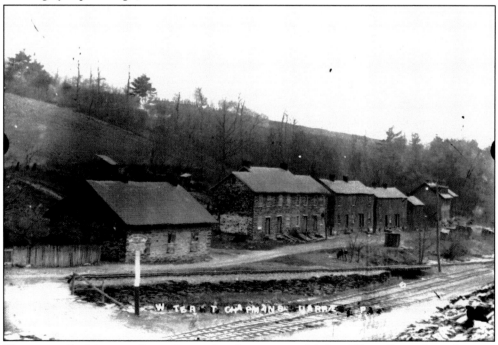

The map calls this street Front Street, the glass negative labels it Water Street, but it became known as Frolic Row. The old schoolhouse is on the left. The stream and railroad tracks are in the foreground. (Laura George.)

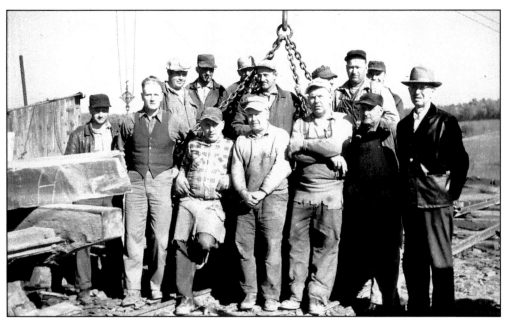

This photograph shows the men working the Chapman Slate Quarry in 1959. In the first row, from left to right, are Howard Barrall, Bert Herd, Bill Beal, Joe Herd Sr., Bill Ducey, Hobart Reinsmith, and Owen Jones. Walter Smith is in the second row at the extreme right. The production peaked at the quarry around 1925 when it employed about 130 men and produced 30,000 squares of slate. (Tim Herd.)

On the Bath-to-Chapman road stands the Herd homestead at 240 Monocacy Drive. Edwin Herd built this house in 1910. The two women, at left, are believed to be Grace "Gram" George and Elizabeth Herd. (Tim Herd.)

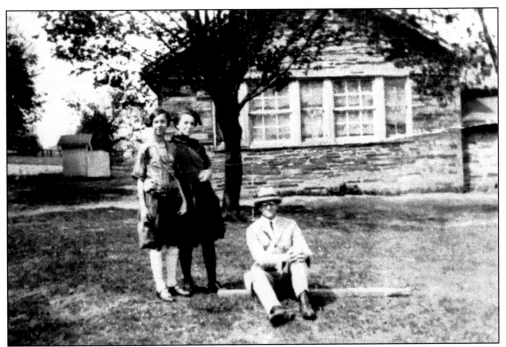

The second school in Chapman was built of slate blocks. Grades one through eight were taught here on Main Street. The 1930s picture above shows the west side of the school with, from left to right, Gladys Jones, Ethel George, and Warren Schall. Gladys Jones later taught here. Below is an early picture of a class in one of the classrooms. (Above, Loretta Kotowski; below, Tim Herd.)

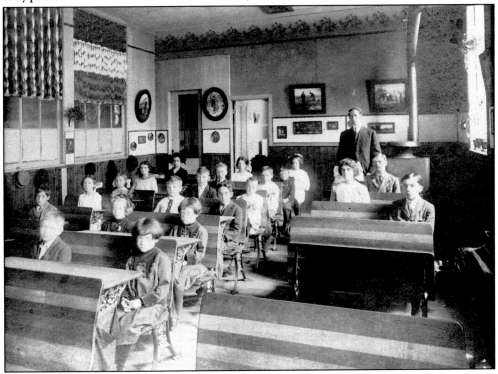

This slate-block house on Main Street is just west of the slate school. It was built around 1845 for the superintendent of the Chapman Slate Company. The house has two Corinthian columns flanking the front door, a bay window in the living room, 10-foot ceilings, and a sweeping staircase to the second floor. (Author's collection.)

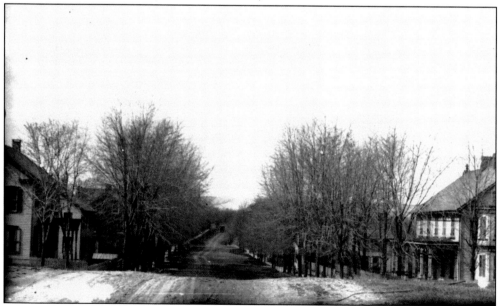

This is an early view north on Main Street. Richard Chapman's house is on the right. In the borough, there are many examples of slate usage: slate sidewalks, slate fence posts, and fancy slate house siding. In 1900, Chapman had a population of 700, all dependent on the slate quarry. The company stipulated that no "malt, vinous, or spiritous liquors" be sold within the borough limits, and today that fact still holds true. (Joseph George.)

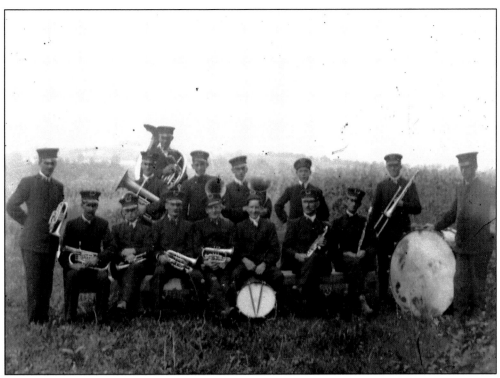

This is a photograph of the Chapman Band, probably from the early 1900s. (Tim Herd.)

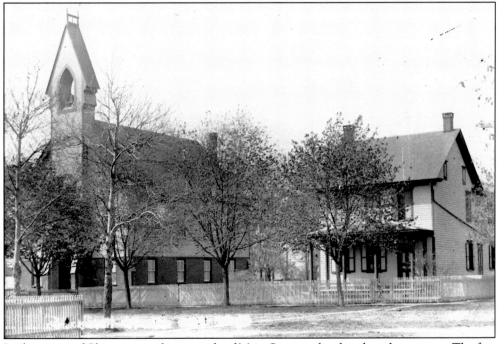

In the center of Chapman on the west side of Main Street is the church and parsonage. The first Methodist Church was built in 1869, but it was destroyed by fire. The present church was built in 1891. (Tim Herd.)

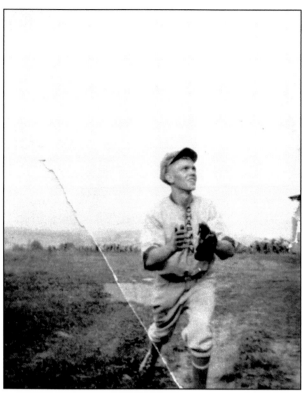

Catching a ball is Mike Michalgyk of the 1923 Chapman baseball team. (Ann Bartholomew.)

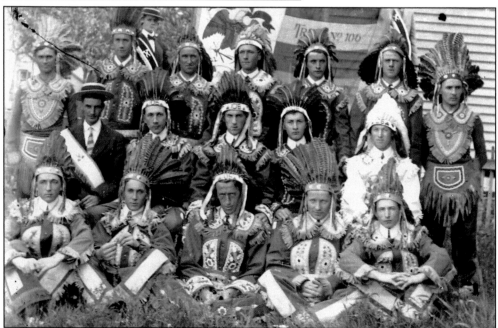

This is a photograph of Chapman's Redman troop No. 106. It was a men's fraternal organization. It had a handbook book that outlined rules and included survivor benefits. At the north end on Main Street, there is a building called Redman Hall, which was probably built and used by this group. Some of the graves in the Chapman Cemetery have Redman markers. (Tim Herd.)

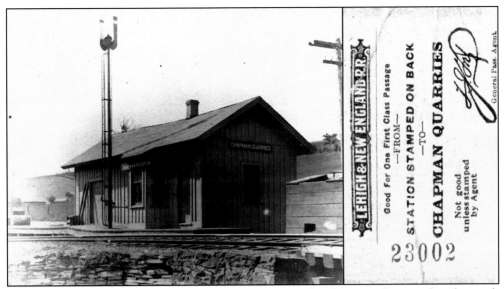

On the left is a photograph of the Chapman Quarry's railroad station that stood at the south end of town. When the trains stopped running, the station was moved and used as a recreation center. On the right is a ticket stamped on the back "L.&N.E.R.R. Dec. 24, 1920, Bethlehem, Pa." (Virginia Bittenbender.)

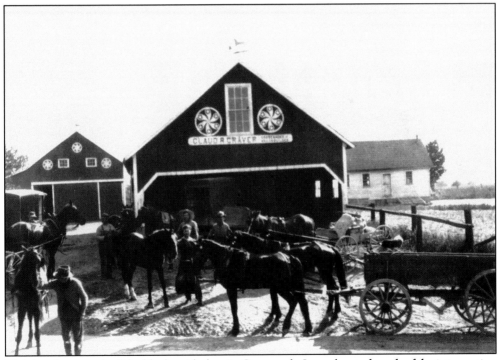

This is a photograph of the blacksmith shop in Crossroads. It was located south of the intersection on the east side. The sign over the barn reads, "Claud R Graver, horseshoer & wagonbuilder." (Ruth Graver.)

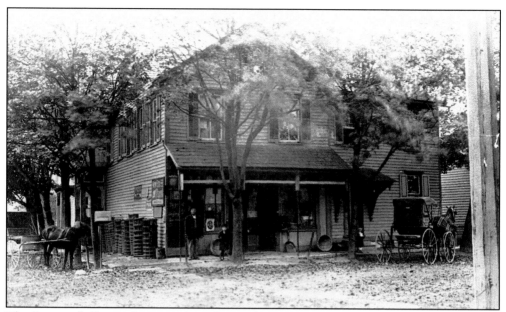

The Crossroads Corner Store stands at the northeast corner in Crossroads. The store was built sometime after 1874, and this photograph dates to about 1900. The window that extends out the left side was the post office where people would come to get their mail. The store is still open for business, and the front porch roof and post office alcove still exist (although covered over.) (Dennis Borger.)

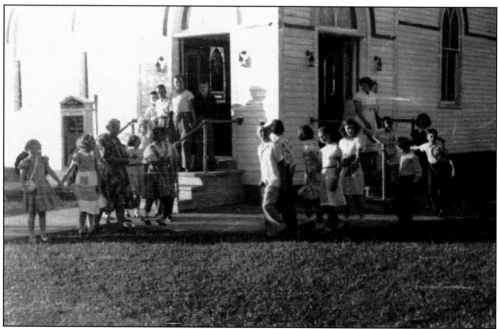

The church in Crossroads ceased being used as a church in 1969. It still stands north of the intersection on the east side. This mid-1900s photograph shows the Sunday school or Bible school children. (Robert Fehnel.)

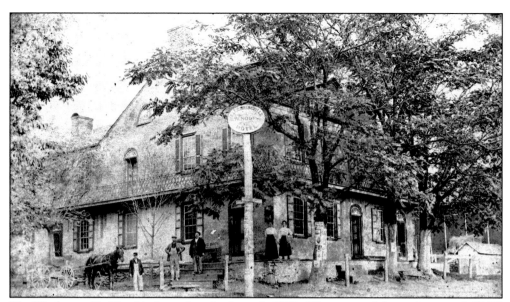

The Klecknersville Hotel is shown here in the early 1900s. The center of the oval sign reads "R W Nolf." The second woman from the right is Erma Nolf. Above her head is a beer sign. The hotel has a second-floor porch with iron railing that extends the full length of the street sides. Note all the paper advertisements tacked to the tree. The hotel and barn still stand on the southeast corner of the intersection of Mountain View Drive and Point Phillips Road. (Sylvia DeRea.)

Early owners of the Klecknersville Hotel shown here are, from left to right, Erma Nolf, son Robert Nolf, and Herbert Nolf. (Sylvia DeRea.)

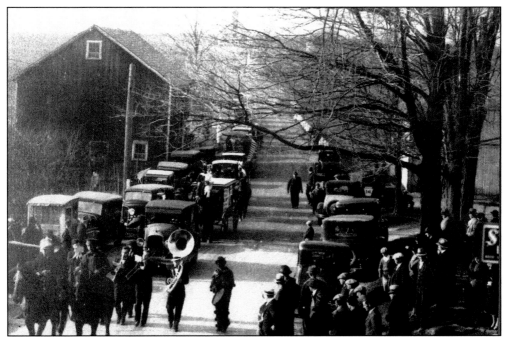

A parade in the early 1900s is heading south on Mountain View Drive into Klecknersville. It started at the one-room school at the center of the picture in the distance, which no longer exists. A crowd (right) has gathered at the front of the Klecknersville Hotel to watch. (Jane Borger.)

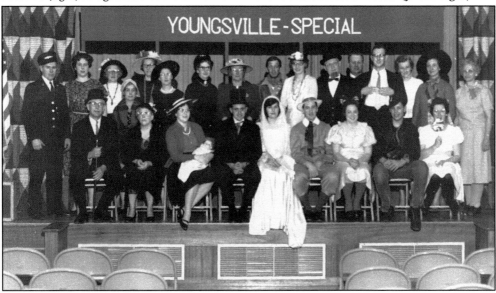

This is the cast of *'S Fohr Uff Der Train*, Pennsylvania Dutch for "driving on the train." It was presented by the Christ Union (Little Moore) Sunday school in the Moore Elementary School in the 1960s. The members are, from left to right, (first row) three unidentified members, Walter Beil, Diane Beil, Leann Derhammer, Claire George, Barry Crock, and Shirley Derhammer; (second row) Jimmy George, Carol Samuels, Mabel Moser, Mamie Stoudt, Dottie Moser, two unidentified members, Gertrude Seip, Burt Beil, Josephine Himmelwright, Merritt Moser, Mark Herman, unidentified, Arlene Moser, Naomi Beil, and unidentified. (Karen Grube.)

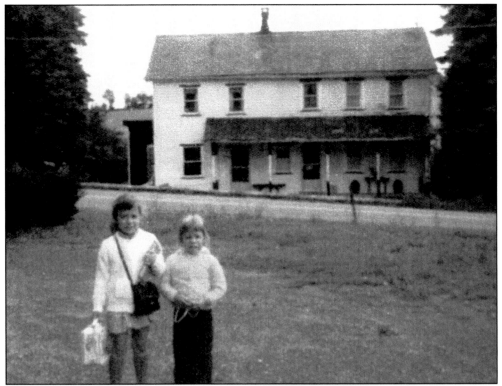

The homestead of Ephriam Young, after which Youngsville is named, lies on the southeast corner of the intersection of Mountain View Drive and South Mink Road. It is a stucco-over-stone house dating to about 1850. Captured in this photograph in 1974 are Jennifer (left) and Chanin Hader, daughters of owner Shirley Hader. (Shirley Hader.)

The Young homestead barn has "hexapod swirling swastika" hex signs on all sides. They are six red stars on yellow circles with white tails on a pale blue background. The house and barn still stand, although the barn has been covered. (Shirley Hader.)

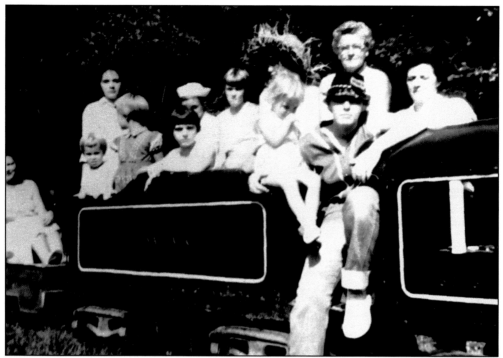

The Iona Park train is loaded and ready to depart. From left to right, the passengers in 1960 are Cindy Silfies, Sharon Rogers, Karen Rogers, Carol Silfies, Trudy Huth, Colleen Hayne, Susan Hayne, Gertrude Seip, and Polly Hayne. Emma and Harvey Moser owned the park in Delps from 1930 to 1960. The park had two pavilions, a food stand, and the train that ran through the woods. Harvey Moser built this train and a smaller train that is now in Ontelaunee Park, New Tripoli. (Sharon Longenbach.)

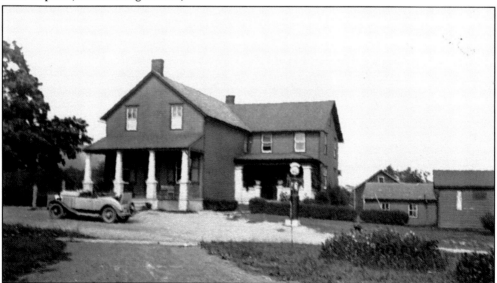

This is an early-1900s photograph of the Moser store in Delps at the intersection of Moser and Delps Roads. It sold groceries, dry goods, and gas. Later Warren F. "Frank" Huth owned and operated the store. The home still stands. (Karen Grube.)

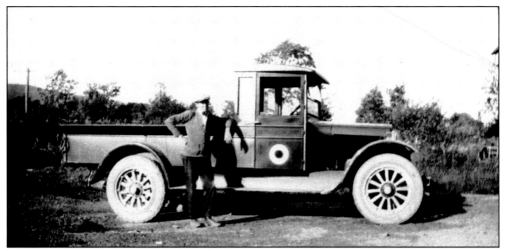

Pictured are Harvey Moser and his coal delivery truck in the 1920s or 1930s. The train ran near his store and dumped coal in the yard, and he delivered it. (Sharon Longenbach.)

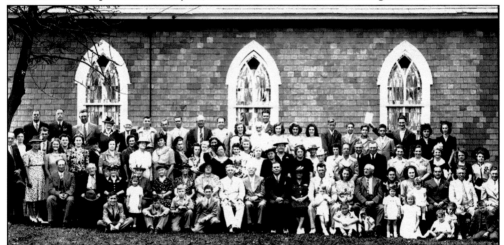

In 1945, the slate-sided United Brethren in Christ Church in Point Phillips celebrated its 62nd anniversary. Members are (first row) Norman Silfies Jr., Elaine Miller, the Sames brothers, Harold Miller, James Miller, Shirley Miltenberger, Eliza Kocher, Joyce Deemer, Peggy Graver, Lillian Waldmann, Thomas Dieter, Mary Ellen Dieter, and Harold Kocher; (second row) Franklin Scholl, Harvey Deemer, Ellen Heberling, Emma Fritz, Lizzie Heberling, Agnes Beers, Ester Hopper, Dr. Enck, Bishop Balmer, Rev. Bowers, Amanda Deemer, Robert Miller, Dorothy Miller, Harvey Shireman, Mamie Deemer, Eleanor Graver, Russel Dieter Sr., Thomas Eckert, and Clifford Graver; (third row) James Welty, Florence Getz, Stella Silfies, Franklin Silfies, Arlene Heckman, Kathyrn Buss, Helen Miller, Jamie Flick, Carie Scholl, Mae Davidson, Laura Beers, Sue Graver, Arlene Waldmann, Helen Graver, Dennis Graver, Mildred Sames, Lottie Wagner, Mabel Kocher, Dorothy Kocher, Dorothy Tanzos, Lottie Kocher, ? Flyte, Hannah Silfies, Meda Danner, Eva Bartholomew, Melissa Walters, Grace Bickert, Harold Kocher, Sterling Bickert, Sylvester Bickert, Erma Bickert, Mildred Eckert, Ellie Eckert, Cora Kromer, and Edith Deemer; (fourth row) Walter Hopper, Charles Getz, Charles Flick, Ida Marsh, Alvin Marsh, Paul Bickert, George Miltenberger, Paul Heckman, Ezra Wagner, Charles Sames, Evelyn Miltenberger, Sam Heffelfinger, Oakley Higley, Miriam Miltenberger, Evelyn Schramel, Isabel Bickert, Harvey Bickert, LeRoy Eckert, Ken Bickert, Russell Dieter Jr., Ken Buskirk, Eleanor Proctor, and Evelyn Kretzman. (Robert Fehnel.)

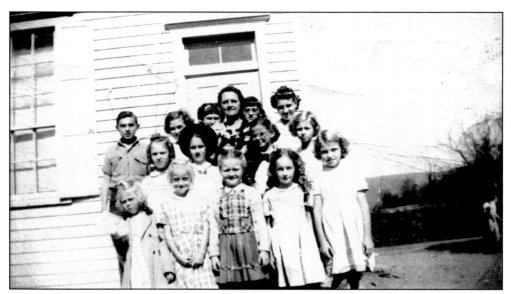

This is Mrs. Bickert and her students at the Point Phillips School in 1950. This picture was taken on the south side of the one-room schoolhouse at Scenic Drive and Millheim Road. The students are Sherwood Heckman, Shirley Miltenberger, Nancy Hahn, Shirley Werner, Pearl Buskirk, Isabell Heckman, Scarlett McCafferty, Marlene Teda, Mae Huth, Stella Buskirk, Arlene Buskirk, Ruth Klipple, MaryAnn Milkovitch, and Janet Huth. They used a coal-fired potbellied stove for heat. In 1874, the schoolteacher was James Marsh, who resided at Marsh's Hotel (Ye Olde Chubbsville House). The school was torn down in the 1980s. (Peter Rohrbach.)

Taking a break in the 1930s on the north side of the Point Phillips Hotel is Ellen "Mammy" Stahley Eckert. The sign over her head reads, "Point Phillips Hotel, Thomas F. Eckert, Prop." She married Thomas, and they operated the hotel for 49 years. They rented the adjoining store on the south side. It was sold to John Miles and Tommy Ford in 1967. The hotel still stands. (Peter Rohrbach.)

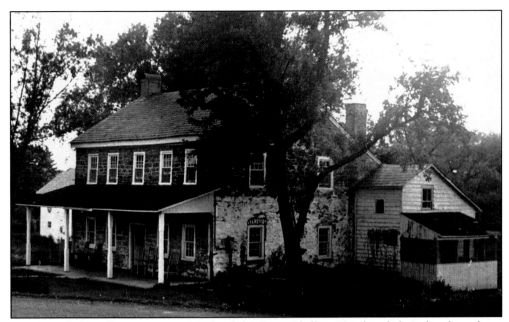

Ye Olde Chubbsville House, just north of the Point Phillips Hotel, is believed to have been built in 1768. It is a stone center-hall house that has been a tavern, hotel, the Hora Lema Camp for boys and girls, and a home. The name comes from its tavern days. The story goes that the proprietor was diluting his liquor with water. And one day when a drink was poured, the customer found a chub (small fish) in his glass. It has been known as Chubbsville ever since. (Peter Rohrbach.)

"Old Dobbin" is taking the girls for a sleigh ride on Point Phillips Road on February 23, 1943. The girls, from left to right, are Ida Milkovitch (Gossler), Dorothy Silfies (Tanzos), and Margaret Milkovitch (Steiner). The horse and sleigh were owned by Sylvester Bickert. (Ida Gossler.)

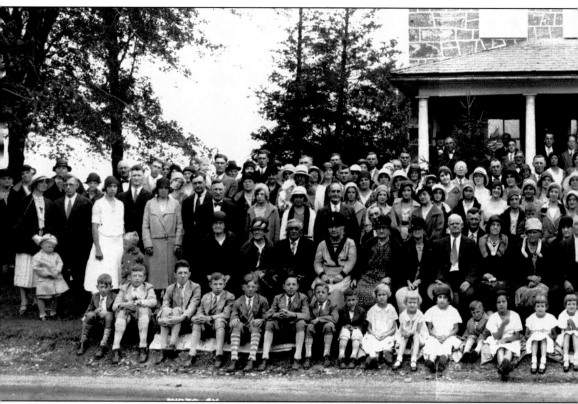

The congregation of Salem United Church of Christ gathered in front of the parsonage on Community Drive in Moorestown for this photograph. The event was homecoming on

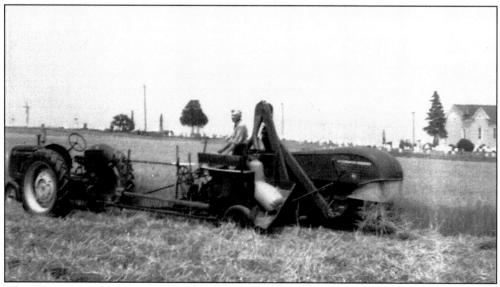

John Werner is riding his 1948 Cockshutt 30 tractor on the Werner farm a half mile west of Moorestown. Taken in the 1960s, the photograph captures a part of Salem United Church of Christ on the right in the background. (Robert Werner.)

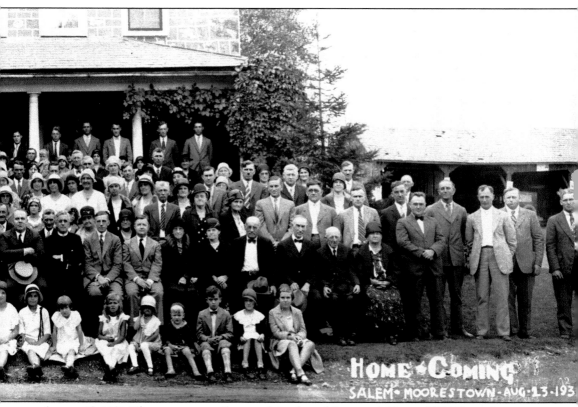

August 23, 1931. The pastors were Reverend Apple and Reverend Clauss. (Bill Werner.)

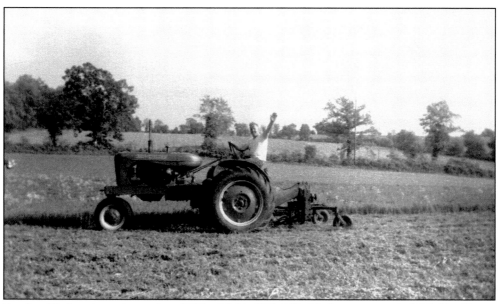

Stephen Harhart is cutting spring alfalfa with his 1939 Allis Chalmers tractor in 1961. His 40-acre farm is located east of Moorestown on Route 946 at Whitehead Road. (Jason Harhart.)

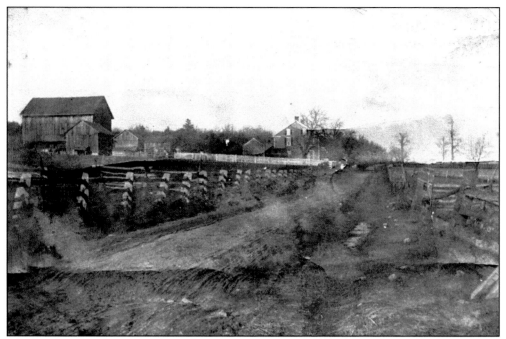

This is a picture of the Charles and Annie Fehnel farm at 351 Moorestown Road in the late 1800s or early 1900s. Route 512 was a dirt road with a wood fence on the right and slate fence posts on the left. (Ann Bartholomew.)

The 1940s deer hunters are, from left to right, (first row) William Nolf; (second row) Pearl Hahn (née Nolf), Herb Nolf, Lester Rinker, and unidentified. (Sylvia DeRea.)

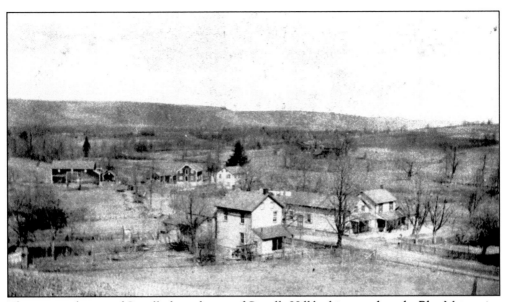

This is an early view of Copella from the top of Copella Hill looking north to the Blue Mountains in the background. It had a gristmill, a cider mill, and a store. Only the store and the grindstones from the mill remain. The store, at lower right, was built by Conrad Eberts in 1870. The date is documented by a date stone on the lower east side of the store. (Edwin Keller.)

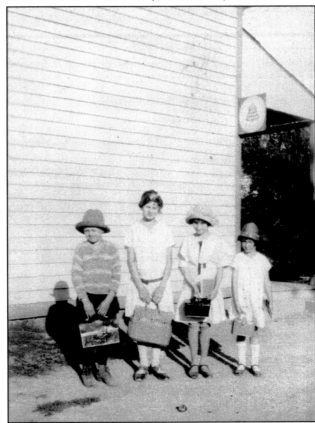

The Copella Store stands at the northeast corner of the intersection. Seen here are the children alongside the store with their lunch boxes after school in the early 1900s. The schoolchildren are, from left to right, Wallace Graver, Eleanor Graver, Emma Beers, and Loretta Knecht. (Joanne Keller.)

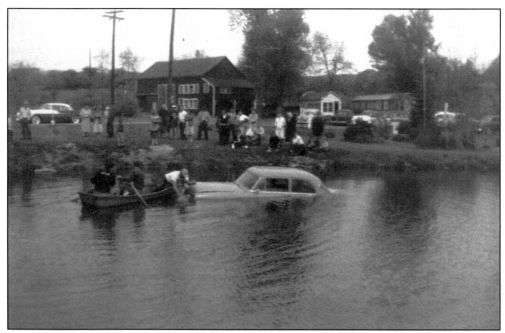

This 1955 photograph shows a car in the pond behind the Copella Store barn. It is all too common an occurrence for a car not to make the sharp curve at Point Phillip Road and Bushkill Drive and slide into the pond. This photograph shows people working to pull the car out Sunday morning, with a crowd, dressed in church attire, watching the action. (Edwin Keller.)

Danner's Grove near Benders Drive along the base of the Blue Mountains had a large swimming pool. The water was spring fed and ice cold. This 1942 picture shows the crowd it drew from Bath, Nazareth, and Northampton on a hot summer day. (Ida Gossler.)

Six

EAST
PENN-ALLEN AND RISING SUN

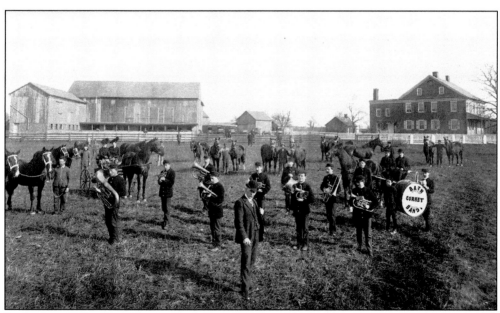

In the late 1890s, Llewellyn G. Dech poses for this photograph in front of the Bath Coronet Band and horses on his property, the Rising Sun. His wife, Laura, and her sister are seated in the buggy on the left. The Rising Sun was built by Capt. Henry Jarrett in 1806. It was the first brick building in this area, and it took two years to build. The bricks were made in the adjoining brickyard. The property still stands a mile east of Bath on the north side of the Newburg (formerly Bath-Easton) Road. (George Dech.)

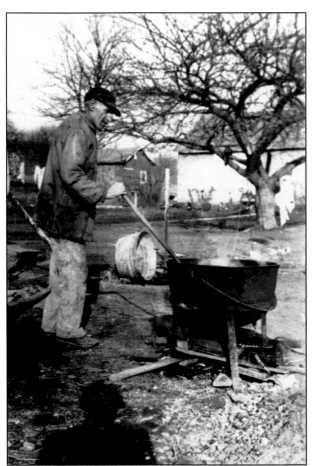

In pencil across the bottom of this photograph it says, "Pappy making lard." Pappy was Thomas Erkinger Sr., and it was 1947. His farm was along Whitehead Road. (Thomas Erkinger III.)

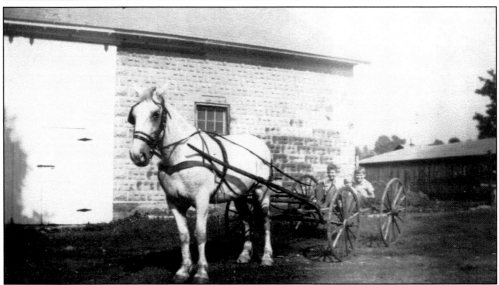

In 1944, Thomas Erkinger Jr., Artie Longley, and "Vicky" Satlov are taking the horse and buggy for a ride. (Shirley Erkinger.)

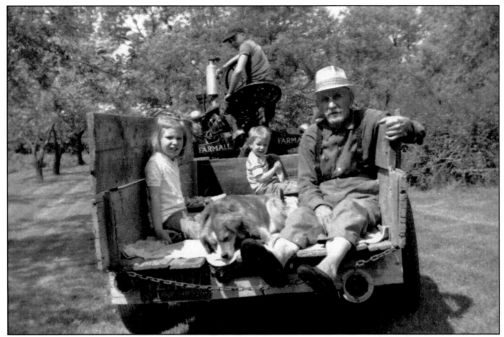

Thomas Harhart is taking the gang for a ride with the Farmall tractor through the orchard in 1963. From left to right, the gang on the back is Kathleen Erkinger, Noop the dog, Thomas Erkinger III, and Thomas Erkinger Sr. (Thomas Erkinger III.)

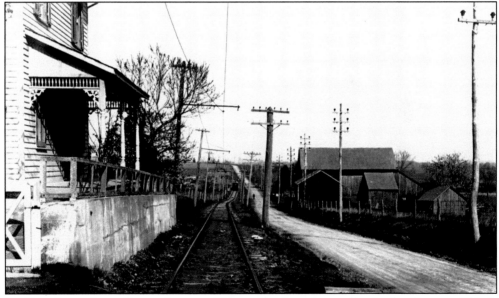

Looking down the trolley tracks toward Nazareth, there is a trolley in the distance. This is where, if one were traveling to Nazareth, one would have to unload and cross the railroad tracks and get on another trolley to complete the trip. The railroad into the Penn-Allen Cement plant would not permit the trolley to cross its right-of-way. The conductor's chant at the transfer point became a running joke because with the thick German accent it came out, "Beslehem, Bass, and Nazarass, don't forget your packagass." (Bath Museum.)

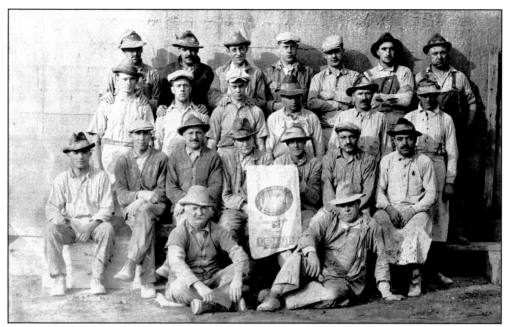

East of Bath was the Penn-Dixie Cement plant. This photograph was taken in the late 1930s in front of the packing house at Penn-Dixie. These men packed cement into bags like the one shown. Only a few of the names are known: in the second row, the first man on the left is Karl Petz, the man on the far right in the third row is Leopold Bessenhoffer, and in fourth row, the man on the far right is Louis Bauer. (Hattie Groller.)

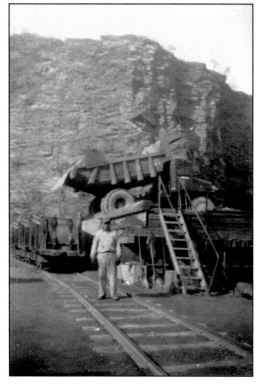

This is a picture of John Rice at the Penn-Dixie quarry, taken April 21, 1952. Note how the trucks backed onto a platform to dump the stone into the railcars. (Doris Burritt.)

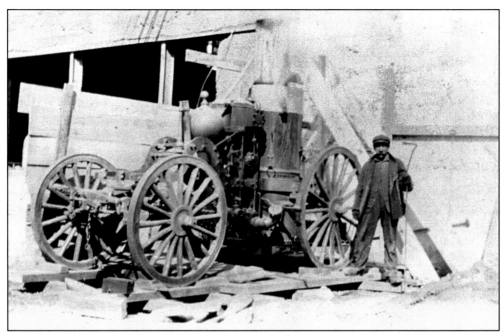

Benjamin Eberly is standing next to the Bath Fire Company steam engine that was used at the Penn-Allen Cement plant to pump water around 1901. (Bath Museum.)

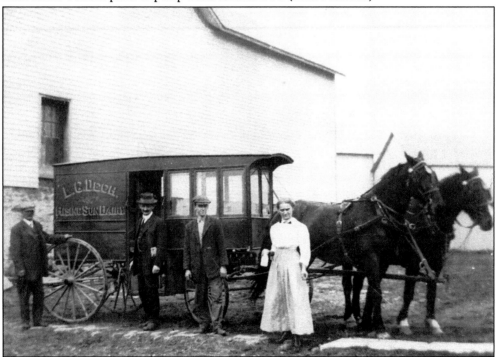

Llewellyn Dech, with his hand on the wheel, is pictured here with his dairy truck in 1900. His wife Laura is on the right. Llewellyn, like many others at this time, had multiple business ventures. He was a farmer, innkeeper, and dairyman, rented horses and buggies, and even did some cement work. (Don Keller.)

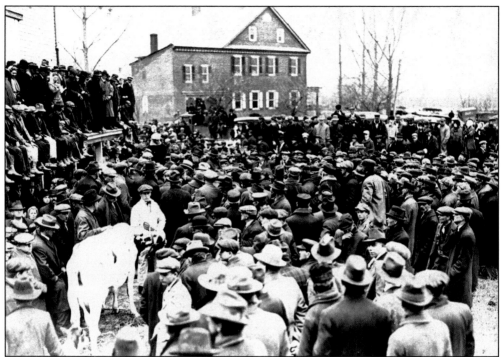

This was one of Llewellyn Dech's famous farm auctions. It was in 1922, and they auctioned farm equipment and livestock. The advertising was done with large posters, and wagonloads of people were driven in from Newburg. To the left, there are men sitting and standing on the flat roof of the barn overhang. The large brick Rising Sun is in the background. Dech had at least one other auction, in 1903, when he decided to give up farming and go back to innkeeping for a while. (Annabelle Dech.)

This is a photograph of the pavilions in Neverseen Park. The park was in the woods north of the farmland of the Rising Sun in the early 1900s. (Carol Keller.)

Seven

SOUTH
IRISH SETTLEMENT

Richard Nye, dressed in his Colonial garb, stands in the doorway of the 1785 Wolf Academy on Jacksonville Road. Nye was president of the GWHS for 15 years and was instrumental in completing the interior of the academy, starting the restoration and the procurement of heat in the Ralston-McKeen House, the acquisition of the Monocacy School, and the founding of the GWHS Museum. (GWHS Museum.)

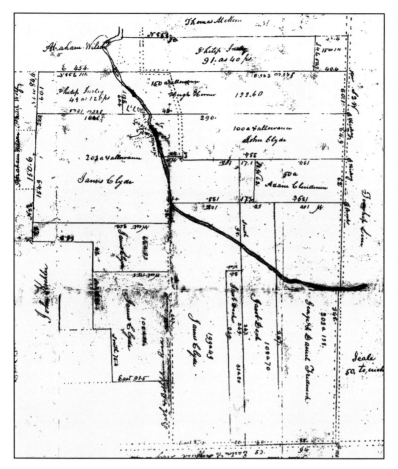

This rare map of the Scotch-Irish settlement dates to the late 1700s or early 1800s. The road (double dotted lines) running through the center, north to south, is labeled "Bath + Bethlehem Road." The road across the bottom is labeled "Easton + Siegfried Ferry Road." Phillip Wolf (upper left), the older and only brother of Gov. George Wolf, purchased the family homestead in 1808. (Author's collection.)

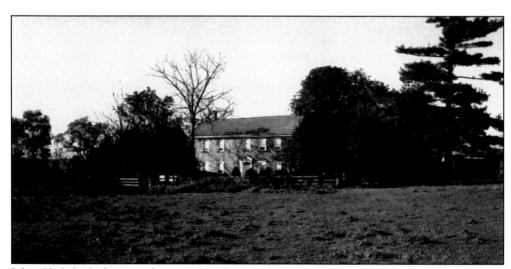

John Clyde built this stone home at 7317 Bath-Beth Pike in two parts, the right in 1767 and the left in 1782. (Author's collection.)

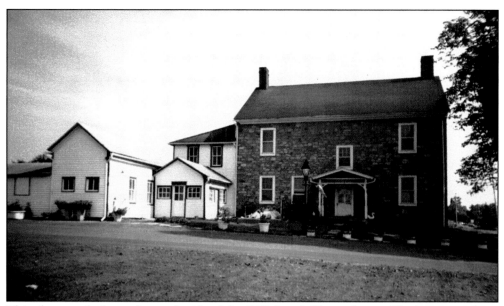

This photograph shows the north side of the 1790 Joseph Horner home. The house stands on the east side of the Bath-Beth Pike, a half mile south of Bath. The chestnut tree, right, is a descendant of the Friendship Tree planted by Jane Horner in the early 1900s. Starting at left, the first frame addition held horses, and they were fed through the small door. The second frame addition was the kitchen for servants, and the third was the porch and cistern. In 1941, it was known as Hazelbrook Farms, the home of quality milking shorthorn cattle. (Edwin Schall.)

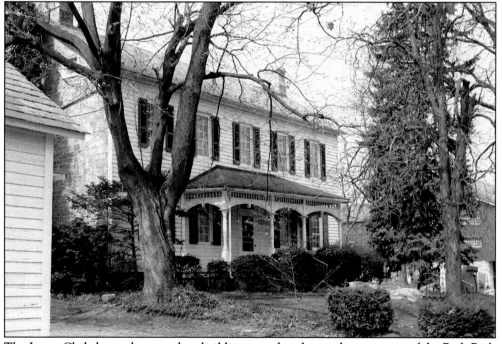

The James Clyde home, barn, and outbuildings stand at the northwest corner of the Bath-Beth Pike and Locust Road. This stone home was built in 1790 and modernized in the late 1800s with wooden siding and a Victorian porch. (Author's collection.)

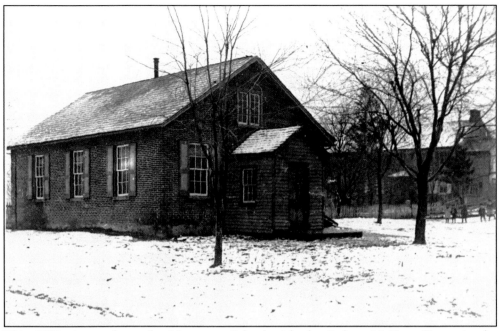

This 1908 picture shows the Monocacy School with the Ralston-McKeen House in the background. These buildings, along with the Wolf Academy, are located at the southeast corner of Jacksonville Road and School Road. The brick school was built on the site of a former log school. Some of the school's students can be seen on the right. (GWHS Museum.)

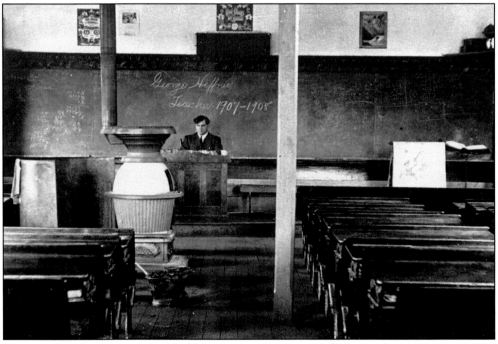

The neat handwriting on the blackboard states, "George Heffner Teacher 1907–1908." The Monocacy School classroom has an old potbellied stove and bucket of coal, desks fastened to the floor, and examples of cursive letters over the blackboard. (GWHS Museum.)

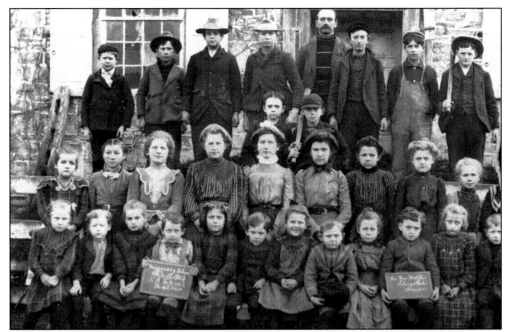

It was common for Monocacy School classes to pose for pictures in front of the Wolf Academy. The left slate reads, "Monocacy School Feb. 12, 1903 T. A. Fehnel," and the right one reads, "Ex. Gov. Wolfe Educated Here." George Wolf, the seventh governor of Pennsylvania, was born in 1777 just west of here and was a student at the academy. His home was a log cabin "one story high and ten story long" in Jacksonville across from the Sign of General Jackson Hotel. He was instrumental in the passage of the legislation that resulted in public education. (GWHS Museum.)

This is a 1940s view of the Wolf Academy. After serving as a place of higher education for 40 years, it became a church, a debating society, a home, and a barn. In 1921, the Northampton County Historical Society offered an automobile outing, starting at the American Hotel, visiting the Wesselhoeft, Kern, Steckel, Scott, Kreider, and Hirst homes, Wolf Academy, Wolf birthplace, 1731 Presbyterian Church and churchyard, Captain Hay's Mill, Fort Ralston, homes of Rev. John Rosbrugh, Jane Horner, Thomas Craig, and Gen. Robert Brown, and the Friendship Tree. (GWHS Museum.)

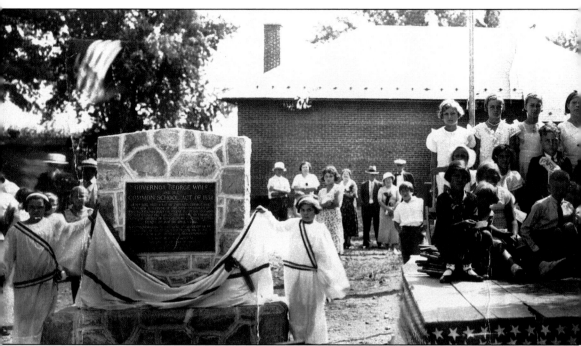

The Gov. George Wolf Common School Act of 1831 monument was dedicated by the Patriotic Order of the Sons of America on August 29, 1934. Behind the platform is the north end of the

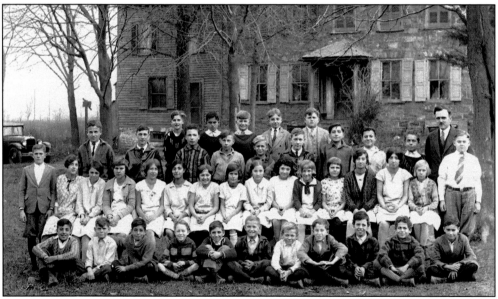

Asa McIlhaney, noted local historian, is shown with his 1931–1932 class in front of the Ralston-McKeen House. McIlhaney taught for over 50 years, was president of the school board, and was a nature lover. The only student known in the picture is Irene Ziegenfus, the second student from the left in the second row. Col. James Ralston built the north (left) one-story part in 1792, and Thomas McKeen added the main center hall part and operated a store in the basement. (Sylvia DeRea.)

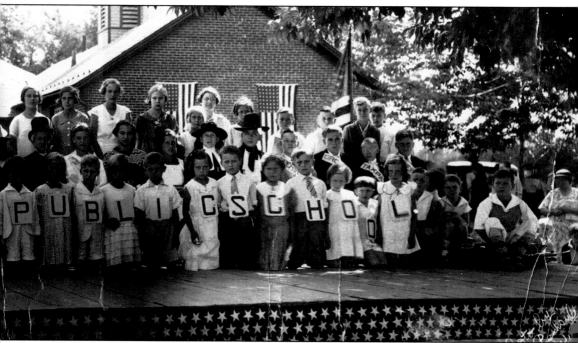

Monocacy School and its later addition on the left. The girls dressed in white unveiling the monument are Vivian Wuchter (left) and Charlotte Unangst. (Dolores Schall.)

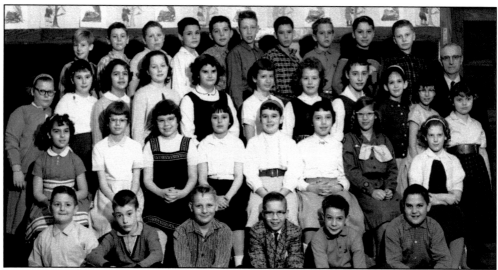

Shown is Warren Dech and his fifth- and sixth-grade class in the Monocacy School in June 1960. Students are, from left to right, (first row) Randy Gangaware, Dennis M——, Gary Meixsell, Lemont M——, James K——, and ? Fenstermaker; (second row) Donna Amore, Jean Eberts, Carol Smith, Mary Stein, Patricia Gontar, Shirley Smith, Susan Spengler, and Susan Z——; (third row) Dorothy Hummel, Janice Doughterty, Louise Smith, Colleen Kelly, Karen Hornberger, Joan Eberts, Karen M——, Judith Boyle, Sharon R——, Karen Lewis, and Diane Groff; (fourth row) Danniel Spengler, James Rabe, James Fallstich, Timothy M——, Ronald Spangler, David Seiple, William Orristen, Charles Kish, Lawrence Shmoyer, and Richard Yelles. (GWHS Museum.)

Pictured is the James H. Horner house at 7514 School Road. James acquired over 139 acres upon the death of his father, Hugh, in 1806. He married Esther Clendinin and had three daughters. In 1813, they began to construct this limestone home, which took two years to complete. It has three corner Federal-style fireplaces and one walk-in. James was a squire and a trustee and treasurer of the English Presbyterian Church. He died at age 44. (Abby Spencer.)

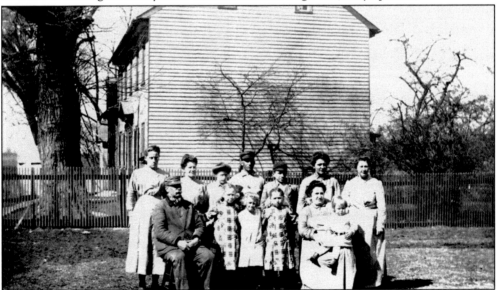

This is the Fehnel family with the east side of the 1782 Hugh Horner home at 7465 School Road in the background. Hugh's mother was Jane Horner, killed by Native Americans in the 1763 massacre. Later Hugh's son Joe lived here. Joe became superintendent of Keystone Cement and moved to Bath, and the house became the Fehnel residence. The Fehnels had 21 children, 11 of whom survived. It is common for the east side of an old stone home to be weatherboarded to keep severe storms from penetrating. (Bruce Swan.)

Eight

WEST

FRANKS CORNER AND WEAVERSVILLE

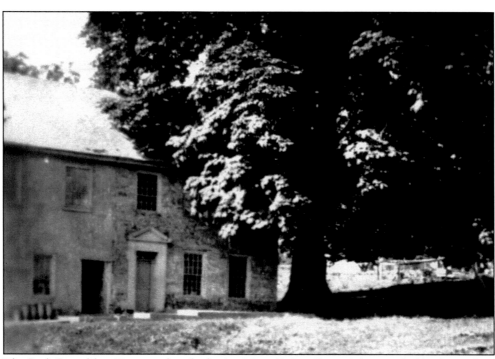

The Bath Friendship Tree stood at the back of Gen. Robert Brown's house a half mile north of the Nor-Bath Boulevard on the east side of Airport Road. In 1785, Col. Henry Lee gave George Washington 12 horse chestnut saplings as a token of friendship, and Washington gave 2 to Brown. By 1920, one had grown 80 feet tall with a circumference of 27.5 feet. Asa McIlhaney nominated it for the Hall of Fame for Trees, saying it symbolized friendship between three patriots who had fought for independence. Shortly after registration, it was hit by lightning and reinforced with concrete. It died in an ice storm in 1953 at age 168. (GWHS Museum.)

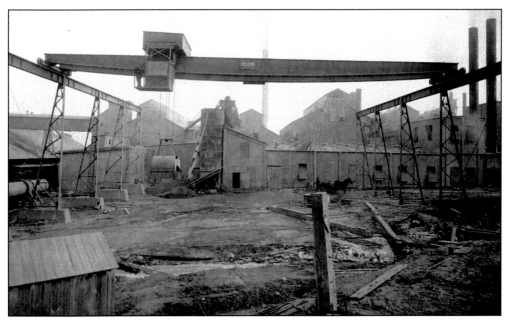

This photograph of the Bath Portland Cement Company was taken in the early 1900s. The Bath Portland was located where Keystone Cement's quarry is at present. Overhead is the crane that carried clinker. Note the horse-drawn equipment in the center. John Michalgyk was one of its employees. (Ann Bartholomew.)

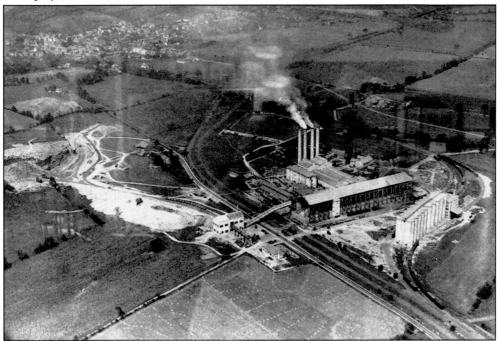

Keystone Cement Company was organized in 1926 and started producing cement in 1928. The road running diagonally through the center of the picture is the Nor-Bath Boulevard. In the upper left, the borough of Bath is visible. Today Keystone employs more than 180 people and produces 700,000 tons of cement annually. (Darrell Mengel.)

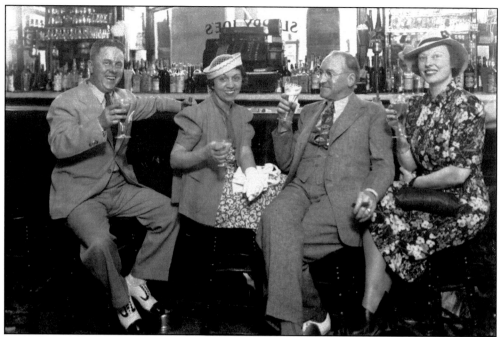

Fred B. Franks Sr. is relaxing with his second wife, Esther Shimer Franks (right), and friends at Sloppy Joe's Bar in Havana, Cuba. The intersection of the Nor-Bath Boulevard and Airport Road became known as Franks Corner after his white home on the northeast corner. He built many cement plants and was the founder of Keystone Cement Company and its wet process. He donated the pipe organ to United Church of Christ in Bath in memory of his first wife. (Susan Derr Kirk.)

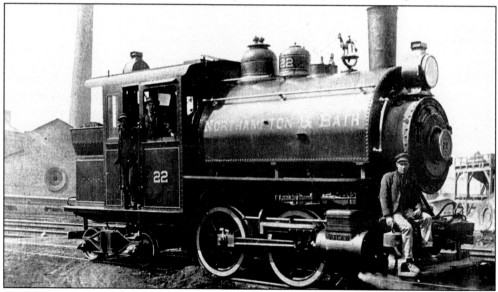

The Northampton and Bath Railroad (N&B) was nicknamed "Nowhere and Back" by Bathites. The N&B started in 1902 but did not carry passengers until 1907. The route was 7.28 miles with the trip taking about 24 minutes. There were five trains and as many as 60 passengers a day. The passengers rode in a specially built dark red coach. The passenger service was discontinued in 1921. The N&B ran for 77 years. (Josef Guenther.)

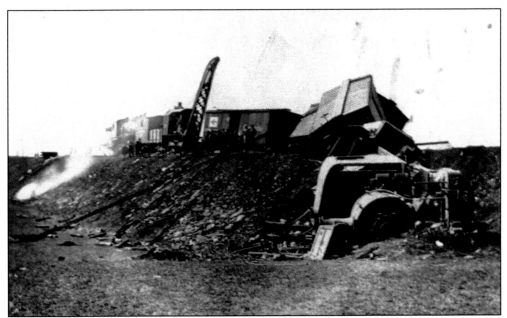

On March 18, 1913, the N&B train wrecked in the S curve just west of Bath Portland Cement. Engineer Charles Hilberg of Siegfried lost his life at age 35. It was three days before his planned retirement from the railroad to a farm with his wife and three children. The engine and six freight cars were derailed; the passenger car and one freight car remained on the track. Over 150 feet of track was torn into splinters. Spreading of the rails was given as the cause. (Steve Hilberg.)

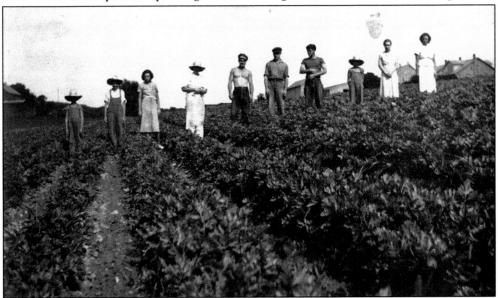

These people are picking celery in Mary O. Newhard's (née Sheffy) field around 1940. Her farm is on the north side of the Nor-Bath Boulevard about a mile west of Franks Corner. The picture was taken looking east, and the house is visible on the right. From left to right, the pickers are Charles Fehnel, Mildred Faust (née Fehnel), Arlene Hennings (née Fehnel), Anna Fehnel (née Newhard), Ray Fenstermaker, Harold Fenstermaker, Frank Schlofer, Warren Fehnel, Agnes Schlofer, and Flora Fenstermaker. (Robert Fehnel.)

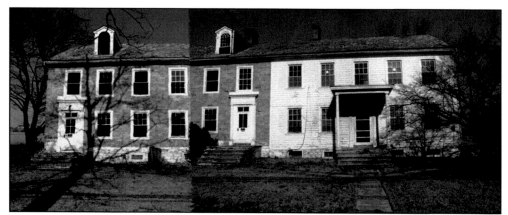

In 1728, Col. Thomas Craig settled along the Catasauqua Creek building log homes. Craig's Settlement, or Irish Settlement, was the first permanent community in Northampton County. Craig built this house, the right side being earlier, in the 1700s. It was just west of the 1813 Allen Township Presbyterian Church on the Nor-Bath Boulevard. As seen here, dismantling has begun, and the house was torn down in 1986. (Peter Rohrbach.)

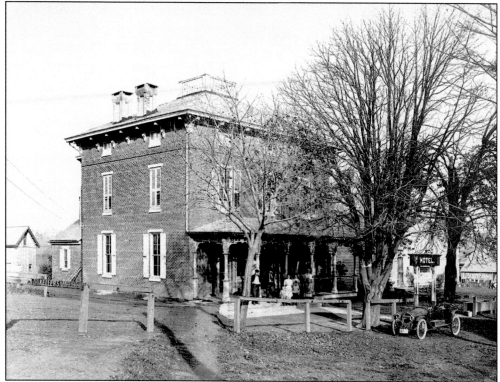

This is the Weaversville Hotel as it looked in the early 1900s. The stone Hays Tavern was the original structure, but the only part that remains is the back summer kitchen and bake oven. Because of the fine springwater here it became known as Hays' Spring or Franklin's Spring. Benjamin Franklin, postmaster general, stayed here frequently on his trips to check the postal roads and offices. Postal service was established from Philadelphia to Irish Settlement in 1775. A note on the photograph claims the car in the picture to be the first car in Northampton County. (Michael Kocher.)

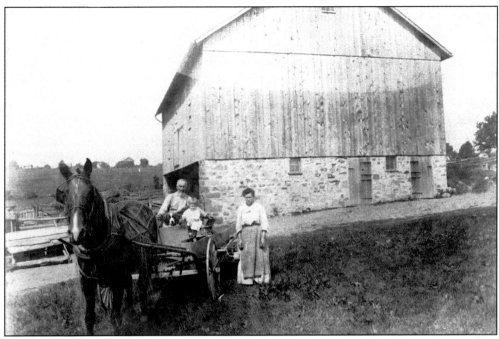

Clinton and Eliza Remaly and their son Mark are shown here in 1917. Their farm is located on Old Carriage Road. Clinton died from a flu epidemic a year later. (Linda Flory.)

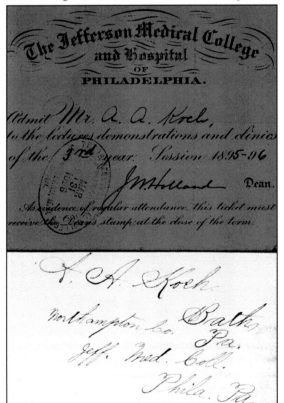

Alvin A. Koch was born in a stuccoed stone farmhouse, which still stands, on the east side of Meadow Road. Shown is his ticket to lectures, demonstrations, and clinics for the third term at Jefferson Medical College in 1895–1896. Koch married Ellen Seiple, and they had a daughter, Tevilla. His practice was in Providence, Rhode Island, but they returned home frequently. The Kochs are buried in the Snyders Church cemetery. Their headstone is an irregular pink stone he had shipped from California. (Rachael Bear.)

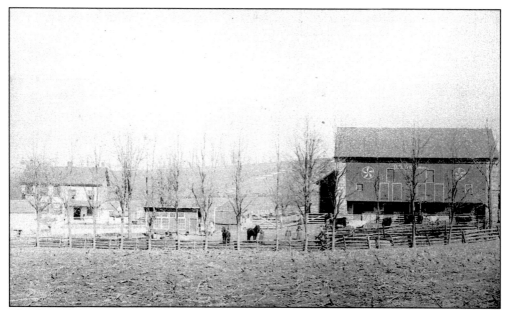

The Samuel Brown house at 5557 Snyders Church Road was built in 1790 and then added to in 1912. The barn was built in 1859. Holding the horses are Alfred Agustus Bartholomew and Laura Knauss Bartholomew. (Brenda Somers.)

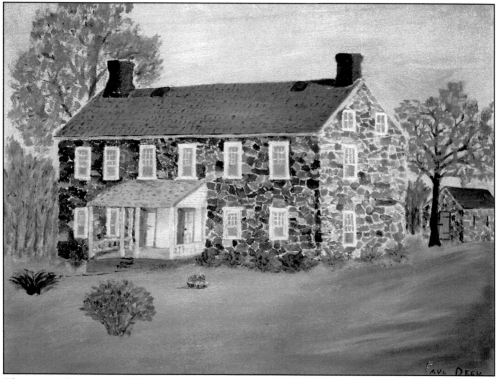

This is an oil painting of the John Snyder homestead painted by current owner Paul Dech. John Snyder's farm was 200 acres, and he had seven children. The homestead was built around 1770 and still stands at 5335 Snyders Church Road. (Paul Dech.)

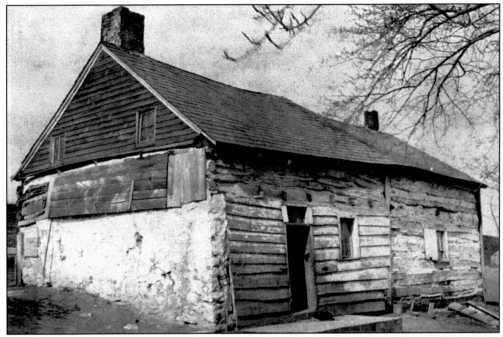

The Hirst log cabin stood at the southeast corner where Snyders Church Road meets West Main Boulevard just west of town. The back of this photograph is inscribed, "Cody – A picture of your Grandfather's home. Please accept with my compliments. H.E. George, Bath April 20, 1902." On the north side of West Main Boulevard, the old road into Bath is still visible. Trees have grown up in the roadway, but remnants of the slate fence posts lining the road still exist. Route 45, now 248, was straightened and concreted in 1926. (GWHS Museum.)

This is a picture of Jacob Hirst, who lived in the log cabin. Nestled around him from left to right are children George, Harold, and Dorothy Bittenbender. The Bittenbender home was on the west side of North Walnut Street and they used to take care of Jacob. He enjoyed entertaining the children. (Mary Ellen Bittenbender.)

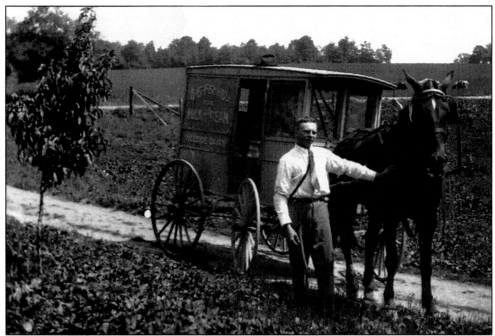

Leo Fehnel is delivering milk and cream to hotels in the 1920s. He bought his farm in 1904 and started his milk route in 1918. He had 266 acres, one of the largest dairy farms in Northampton County, and he was one of the last people to use horses for farming. The lettering on the truck is "E.E. Fehnel, Pure Milk & Cream, Hillside Dairy." Note the money bag strap and his hat on top of the truck. (Robert Fehnel.)

Leo Fehnel and his family and farm are featured in this tractor advertisement as progressive Pennsylvania potato growers. Fehnel also had several inventions, including a stone crusher and a self-propelled potato harvester. (Robert Fehnel.)

125

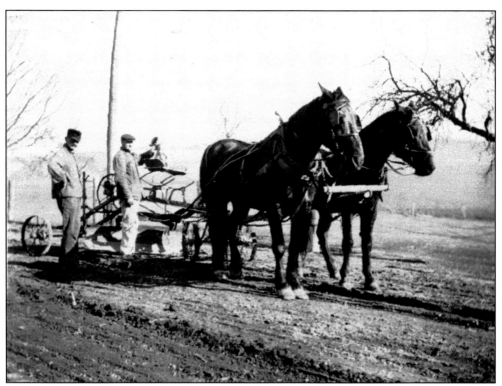

Dirt roads were prone to ruts and holes. A grader was used to level the road surface. This photograph shows Henry Fehnel and Palmer Woodring, roadmaster for East Allen Township, grading the road. (Robert Fehnel.)

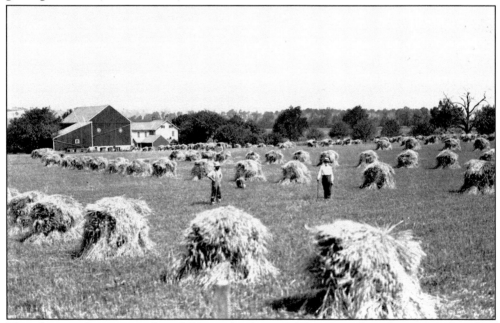

This photograph captures wheat fields on the Amos E. Flory farm along Route 248. Standing among the stacks are Flory (left) and Peter Fehnel. (Robert Fehnel.)

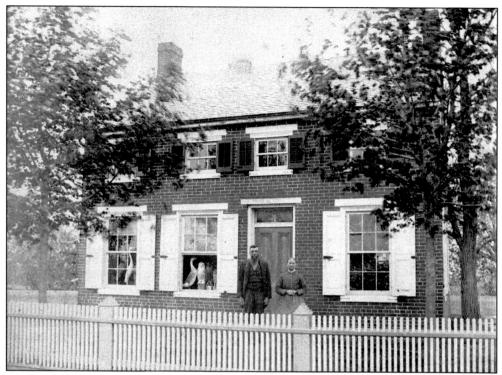

Jacob Schall and his wife stand at the front of their brick house, built around 1800. The birds in the windows were from a friend, Jacob Godshalk, who was a taxidermist near Philadelphia. These were birds that were never paid for and collected by customers. The house still stands along the south side of Mauch Chunk Road, now Route 248. (Evelyn Becker.)

Russell and Eva Becker are picking potatoes in the late 1940s. They had 40 acres that they dug by hand. The tractor is an Oliver 70 hardpan. (Carl Becker.)

This vintage postcard is the perfect ending. (Elizabeth Fields.)